A SPIRITUAL DESTINY

FROM OUR BEGINNINGS

I AM HUMAN

IF THERE IS NO STRUGGLE

BLACKMEN

STRETCH YOUR WINGS

image

ONLY THAT YOU LOVE

IN THE IMAGE OF GOD

LEADERSHIP, THE SKILL AND THE WILL

EVERY TOMORROW, A VISION OF HOPE

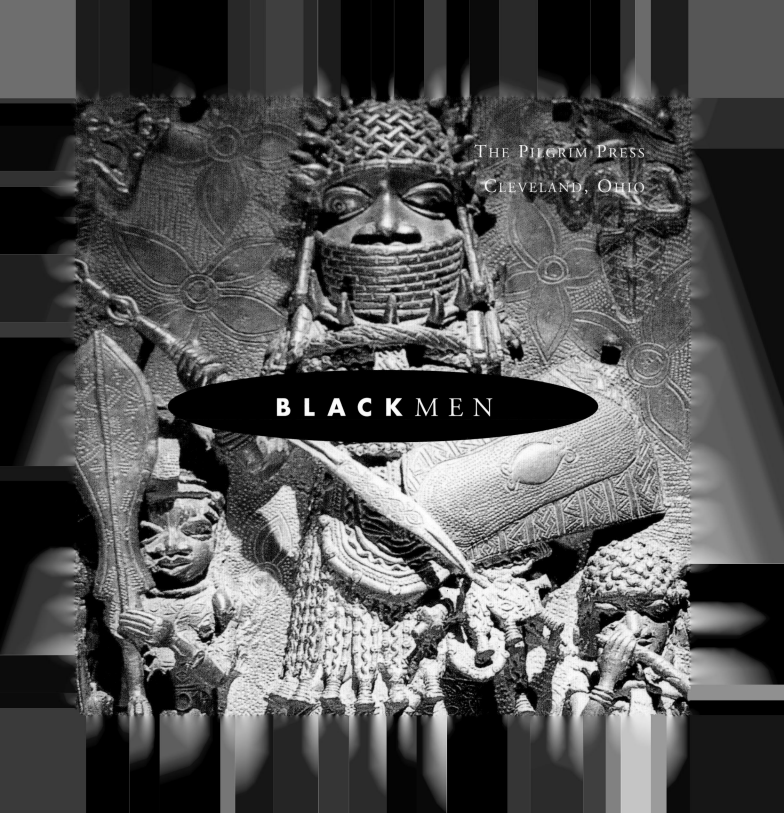

THE PILGRIM PRESS
CLEVELAND, OHIO

BLACKMEN

The Pilgrim Press, Cleveland, Ohio 44115
© 1999 by Dorothy Winbush Riley

Printed in China on acid-free paper

04 03 02 01 00 99 5 4 3 2 1

Library of Congress Cataloging-in-Publication Data
Black men in the image of God / edited by Dorothy Winbush Riley.
 p. cm.
 ISBN 0-8298-1256-3 (pbk. : alk. paper)
 1. Afro-American men in art. 2. Afro-American men in literature. I. Riley, D. Winbush (Dorothy Winbush)
 NX652.A37 B63 1999
 700'.4520396073—dc21 98-54156
 CIP

CONTENTS

ACKNOWLEDGMENTS

My greatest thanks go to:

Ted Riley, my son, who was the reason this book for African American men was envisioned. Ted, I love you and I am proud of your accomplishments. Stay centered and focused with the knowledge that your strength is from the Creator.

Tiaudra Riley, my daughter, who inspired me to create a book for African American women that was as beautiful as the one for men, who wisely encouraged me with wisdom unusual in one so young.

Schiavi Riley, my firstborn, who looks at me with awe, then questions what I do so that I stay grounded and real. I marvel at your talent and perseverance—when you decide to complete a task, it is done.

Martay Fleming, my nephew, and Nandi Riley, my granddaughter, whose questioning eyes motivated me to complete each book.

Special thanks for art go to:

Brenda Stroud, Elwyn Bush, and Donald Calloway, who opened their private collections to me; the generous spirits of Jonathan Green (Naples, Florida), Mike Colt (Los Angeles), Earl Jackson (Ann Arbor), Sophia LaCroix (Miami), and La Shun Beal (Houston), who became supporters and friends in creating this book.

Special thanks for poetry go to:

Judy Griffie, writer, whose genuine support, love, and understanding of the circle of love bonds us as kindred spirits.

Naomi Long Madgett, poet, whose love of writing and kind words inspired me through the years to have the courage to write and to be published.

Special thanks to Pilgrim Press and its associates go to:

Kim Sadler, my editor, who understood my desire and shaped this volume from more than three hundred pages and photographs.

Martha Clark, art director, who designed the book and made each page a marvel to behold.

Marjorie Pon, managing editorial, who shepherded the book along its way.

Madrid Tramble, production manager, who orchestrated the production from idea to printed book.

Nancy Tenney, copyeditor, who scrutinized every period, comma, and question mark.

ACKNOWLEDGMENTS

INTRODUCTION

The idea for *Black Men in the Image of God* came to me after I researched and completed *The Complete Kwanzaa*. I started two other projects, but my mind kept returning to *Black Men in the Image of God* and the principle of *Umoja*. Through practicing Kwanzaa, I have come to believe that, despite the disconnectedness of the world, God—or whatever name you choose to call the Supreme Being—is in control and has blessings for all who seek them. Unity, for humankind, lies in the realization that man and woman are God's direct descendants. We are all created and made in God's image. God is spirit; humans, as God's likeness, reflect God's nature in love, truth, and freedom without any distinctions between people. "There is neither Jew nor Greek, there is neither bond nor free, there is neither male nor female: for all are one in Christ Jesus."

In 1872, a nine-year-old boy of the Oglala Sioux people had a vision of how God binds all humankind together. Years later in his book *Black Elk Speaks,* he said:

And while I stood there I saw more than I can tell and I understood more than I saw; for I was seeing in a sacred manner the shapes of all things in the spirit, and the shape of all shapes as they must live together like one being. And I saw that the sacred hoop of my people was one of many hoops that made one circle, wide as daylight and as starlight, and in the center grew one mighty flowering tree to shelter all the children of one mother and one father. And I saw that it was holy.

Truth produces change and growth, but we distort it perpetually. For this reason, if none other, people of color must be careful of the messengers and the messages of criticism and condemnation that bombard the world. We must return to the faith of our ancestors and believe the prophet Malachi, who stated that God is the common ancestor of all: "Have we not all one parent? Hath not God created us? Humankind is inseparable from God. God is the cause and we are the effect. God is the unseen with all gifts, powers, attributes and abilities that are mere reflections of God's divine qualities."

Black Men in the Image of God is a celebration of truth, as well as a gift book created to provide powerful images and words of inspiration. Artists have great power to transform and express ordinary experience and faith through poetry, photography, song, sculpture, or paintings. In looking at the art and photographs, we celebrate because, despite a perilous history, African Americans survive, endure, and prosper. May you be blessed as you contemplate and absorb *Black Men in the Image of God*.

X

Then God said,

"Let us make humankind in our image,

according to our likeness;

and let them have dominion over . . .

the earth."

So God created humankind in God's image,

in the image of God, God created them;

male and female

created God them.

—GENESIS 1:26–27

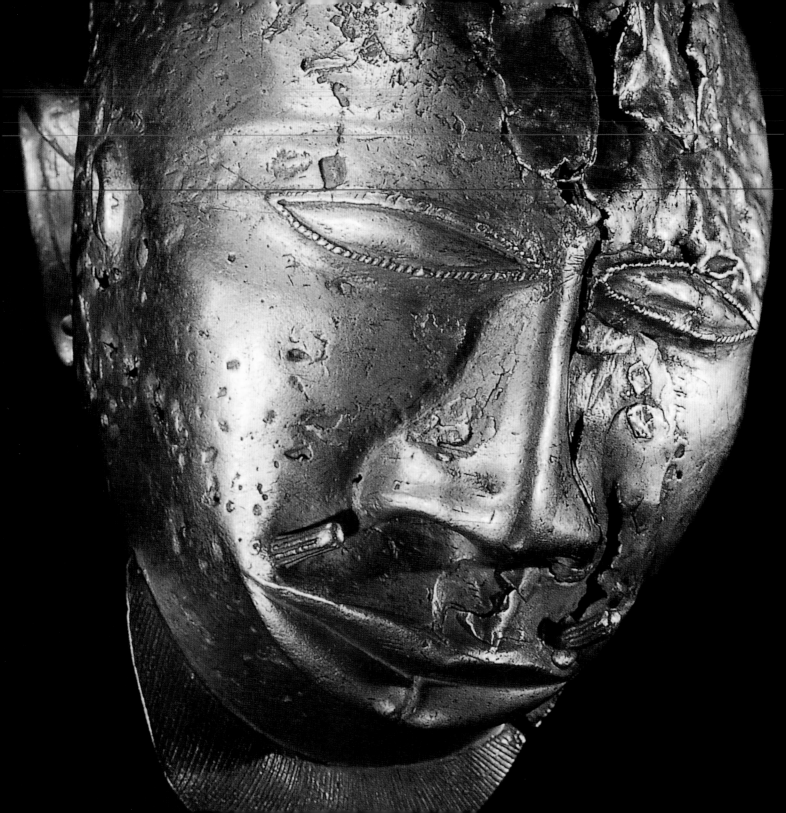

A SPIRITUAL DESTINY

Man's destiny is a spiritual DESTINY and God is not merely *transcendent* but also immanent, deeply involved in the affairs of men since men are made in his image, each with a SPARK OF THE DIVINE and a human personality always maintaining that divine potential.

—MARGARET WALKER ALEXANDER

He who would be
friends with god
must remain alone
or make the whole
world his friend.

friend

—Mohandas Gandhi

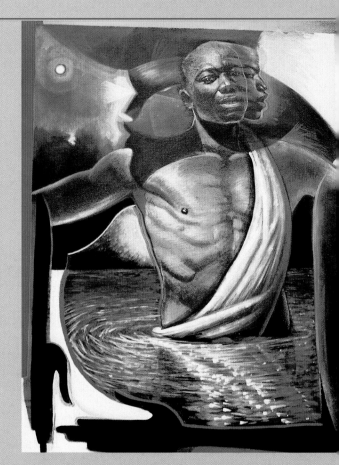

Pheoris West, *Baptism of Christ*

2

3

Who learned the first man on earth?
God,
He is unchangeable, and
if he learned the first man
he can learn you.

—ALICE WALKER

we speak a common language—you and I

it is called Son-speak

we use it to define and describe

our beautiful, African Son-gods

we share a common vision—you and I

the vision of Son-shine and Son-beams

that scatter throughout this earth space

and make of our lives a Son heaven

how glorious to witness a Son-rise

wallow in Son light

wait for a Son dance and

watch as he takes those first steps—alone

some rise early in life's morning

and some later in the day

but rise they do

we share a common prayer—you and I

a plea for no more Son-downs and Son-sets

a petition for Son-up after Son-up

Son day after Son day

we feel a common bond—you and I

it is a wondrous Son love

that warms us with Son rays

and grand Son ways

and holds us captive

making us Son-wise and Son-struck

Forever

—JUDITH BOSWELL GRIFFIE

Henry O. Tanner, *Flight from Egypt*

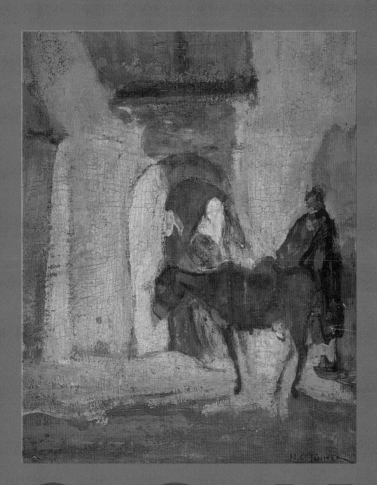

common vision

With his head in his hands,
God thought and thought,
Till he thought, "I'll make me a man."
Up from the bed of a river
God scooped the clay;
And by the bank of the river
He kneeled Him down;
And there the great God Almighty
Who lit the sun and fixed it in the sky,
Who flung the stars to the most far corner of the night,
Who rounded the earth in the
middle of his hand;
This Great God,
Like a mammy bending over her baby,
Kneeled down in the dust
Toiling over a lump of clay
Till he shaped it in His own image;

—James Weldon Johnson

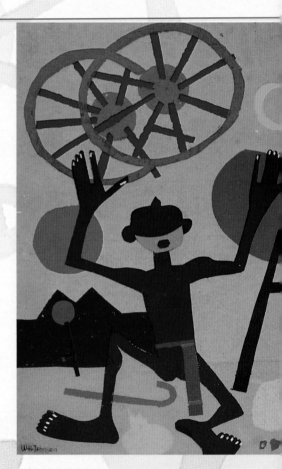

William H. Johnson, *Ezekiel Saw
the Wheel*

A SPIRITUAL DESTINY

His name may not be Moses but the character of the role that he plays is always the same. His name may be Moses or Joshua or his name may be David, or his name, you understand, may be Abraham Lincoln, Frederick Douglass or George Washington Carver, but in every crisis God raises up a Moses, especially where the destiny of his people is concerned.

—Rev. C. L. Franklin

Man, in all ages and all nations of the earth, is the same. Man is a peculiar creature—he is the image of his God, though he may be subjected to the most wretched conditions upon earth, yet the spirit and feeling which constitute the creature, man, can never be entirely erased from his breast, because the god who made him after his own image, planted it in his own image, planted it in his heart; he cannot get rid of it.

—David Walker

8

A SPIRITUAL DESTINY

Elwyn Bush, *Bust of Tutankhamun*

Opposite: Earl Jackson, *Rainbow Maker*

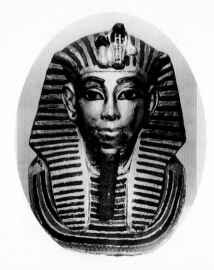

Your hands made me and fashioned me:
 show me the truth,
 and the wisdom to know your will.
Let the people who love you see me and be glad;
for they will know that I am your messenger;
that I come to speak your words.

—FROM PSALM 119

Opposite: *Reverend Horace Sheffield III*
Donald Calloway, *Angel Rising*

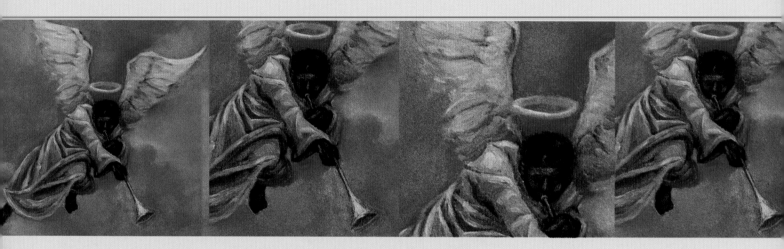

I, too, am a mortal man, like all of you,

descended from the first born,

Formed out of the earth in

my mother's womb.

When I was born, I breathed in the common air,

was laid upon the ground,

and wailed out a cry as all others do,

No king begins life in any other way;

For everyone comes into this world by one path

and by the same path they go out again.

Seeing this predicament, I prayed

and wisdom was given to me.

—WISDOM OF SOLOMON

WISDOM

10

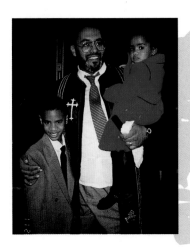

I heard recalled the lofty deeds of my father's ancestors and their names from the earliest times. As the couplets were reeled off it was like watching the growth of a great genealogical tree that spread its branches far and wide and flourished its boughs and twigs before my eyes.

—CAMARA LAYE

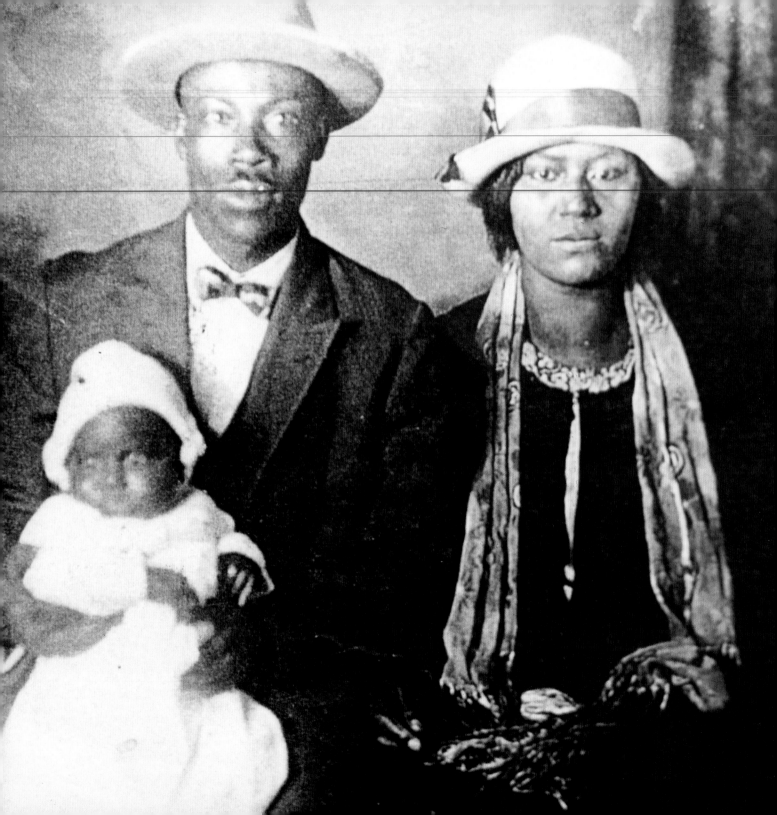

FROM OUR BEGINNINGS

Man

must be born and reborn to belong.

Their bodies must be

formed of the dust of their

forefathers' bones.

—Chief Luther Standing Bear

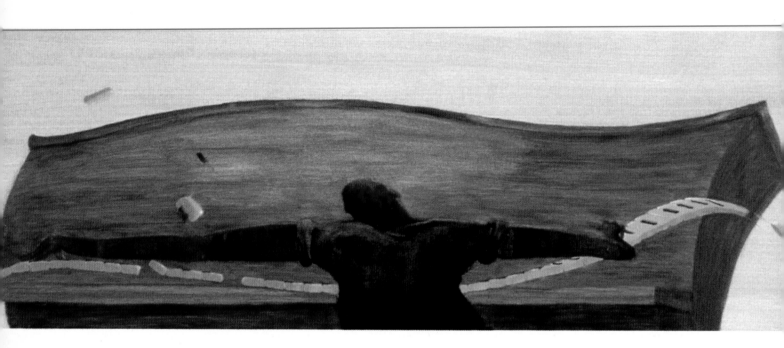

All roads lead back to starts, to where
 I started out, to stars: to fiery
 beginnings of our ends & means: our
meanness and our meaning?

—AL YOUNG

14

15

Ever since Man first began to think,

he began to wonder about

the origin of the stars,

the sun, the mountains, the seas, and

the miracle of life in them, and

he wove shining legends about all this.

In the land of the Barotse

there are those that say

Man originated from a great tree

and grew in the middle of the desert,

while in the land of the Botswana

they say Man and the animals

crawled out of a great hole in the ground.

And in KwaZulu

we believe Man originated

from a great reed that

grew on the banks

of a mighty river.

—CREDO MUTWA

WONDER

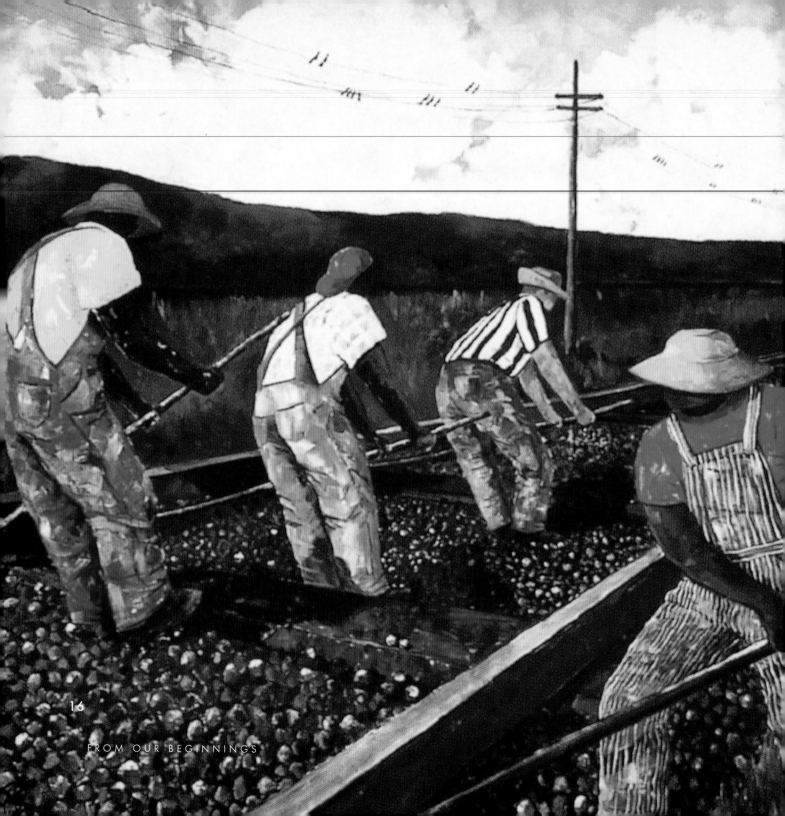

16

Jonathan Green, *Gandy Men*

my hands laid stones

for the foundation of the world.

I've merited my bread.

—Antonio Agostino Neto

i am a marching black.

marching
black

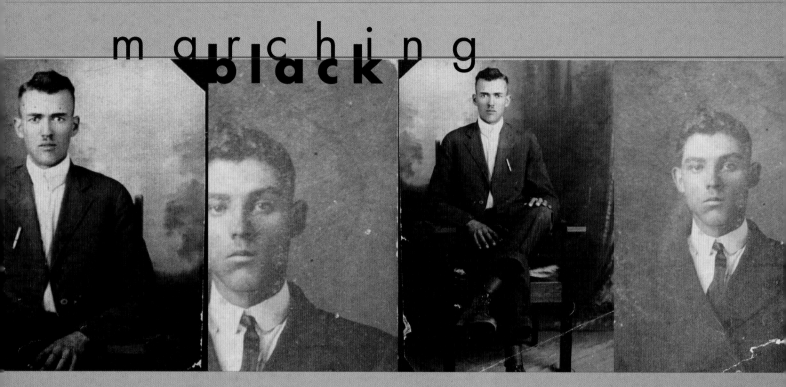

i am a product of—the sustained indignation of a branded grandfather, the militant protest of my grandmother, the disciplined resentment of my father and mother, and the power of mass action of the church. . . .

i am a marching black.

—ADAM CLAYTON POWELL JR.

18

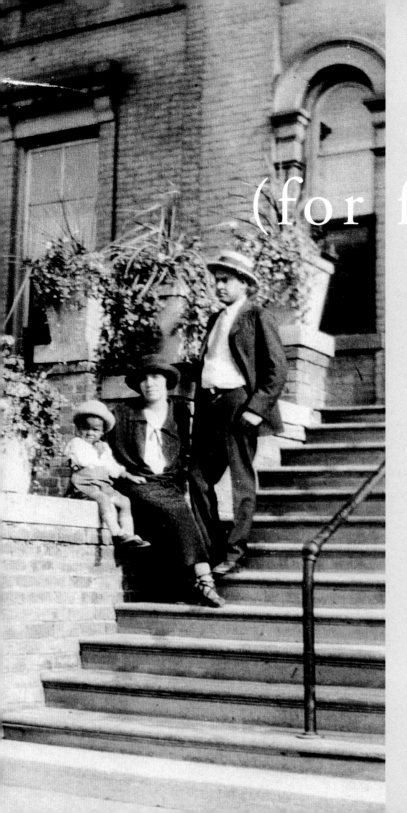

the kind of man he is
(for fred)

the look of him
the beauty of the man
is in his comings and
his goings from
something is black
in all his instances
he fills
his wife with children and
with things she never knew
so that the sound of him
comes out of her in all directions
his place
is never taken
he is a dark
presence with his friends
and with his enemies
always
which is the thing
which is
the kind of man he is.

—LUCILLE CLIFTON

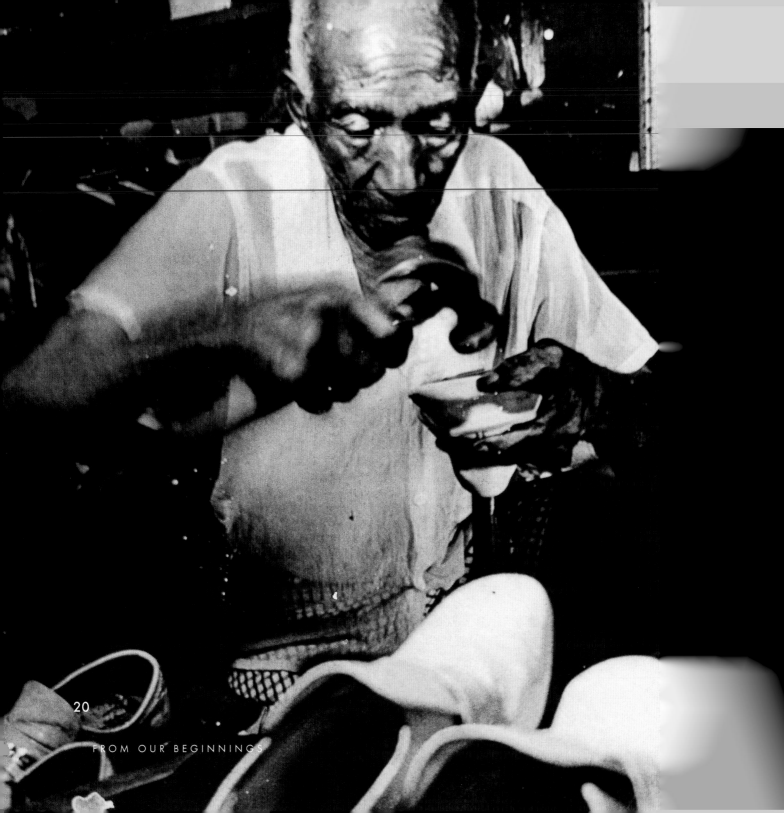

20

Lewis Carter, Cobbler

What can one man do
in a day,
 in a world,
 in a life,
Amidst the ever swirling chaos
Which threatens to engulf
The "Souls of Black Folk"
Leaving an empty husk in its wake.
What can one man say,
 to inspire,
 to awaken,
 to instill
The Spirit which rules kingdoms
The Mind which created knowledge
 The Heart which created hope
All the elements needed

To elevate his people to the crown.
What can one man be,
 To a race,
 To a people,
 To a boy,
In a world that values money over love,
That promotes violence before understanding
And oppression over compassion.
What can one man
 do,
 say,
 or be,
To make a much needed difference,
One man can stand as an example
for a Generation to follow.

—UNKNOWN

inspire.

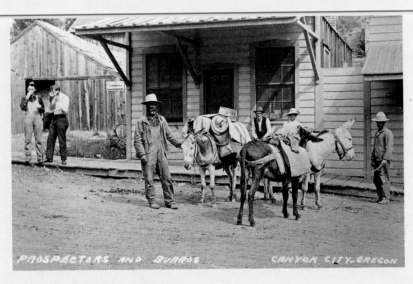

PROSPECTORS AND BURROS CANYON CITY, OREGON

Columbus Sewall, 1822–1863,
Pioneer and Miner

And so we stand here today at this
 historic moment.
We are standing in the place of
 those who could not make it
 here today.
We are standing on the blood of
 our ancestors.
We are standing on the blood of
 those who died in the Middle
 Passage,
who died in the fields
and swamps of America,
who died hanging from trees
in the South,
who died in the cells
of their jailers,
who died on the highways,
and who died in the
fratricidal conflicts and
rages within our communities.
We are standing on the
sacrifices of the lives
of those heroes,
that we today may accept the
 responsibility that life
imposes upon each traveler.

—LOUIS FARRAKHAN

22

EVERYTHING IN THIS SOCIETY IS
GEARED TO KEEPING A BLACK BOY FROM
GROWING TO MANHOOD, BUT HE HAS
TO TRY FOR HIMSELF.

—JOHN OLIVER KILLENS

Everything in this society is geared to keeping a Black **boy** from growing to **man**hood, but he has to try for himself. Everything in this society is geared to keeping a Black **boy** from growing to **man**hood, but he has to try for himself. Everything in this society is geared to keeping a Black **boy** from growing to **man**hood, but he has to try for himself. Everything in this society is geared to keeping a Black **boy** from growing to **man**hood, but he has to try for himself. Everything in this society is geared to keeping a Black **boy** from growing to manhood, but he has to try for himself. Everything in this society is geared to keeping a Black **boy** from growing to **man**hood, but he has to try for himself. Everything in this society is geared to keeping a Black **boy** from growing to **man**hood, but he has to try for himself. Everything in this society is geared to keeping a Black **boy** from growing to **man**hood, but he has to try for himself. Everything in this society is geared to keeping a Black **boy** from growing to **man**hood, but he has to try for himself. Everything in this society is geared to keeping a Black **boy** from growing to **man**hood, but he has to try for himself. Everything in this society is geared to keeping a Black **boy** from growing to **man**hood, but he has to try for himself.

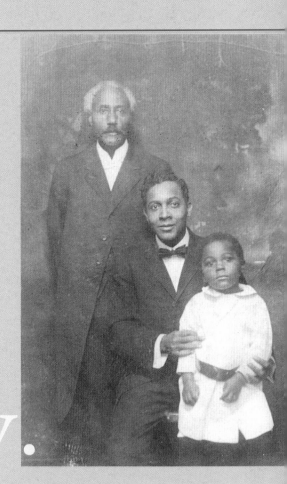

Grandfather,
look at our brokenness.
We know that in all creation
only the human family has
strayed from the Sacred Way.
We know that we are the ones
who are divided and
we are the ones who must come
back together to walk the Sacred Way.
Grandfather, Sacred One,
teach us love, compassion, and honor.
That we may heal the earth
and heal each other.

—Ojibway Prayer

sacred way.

24

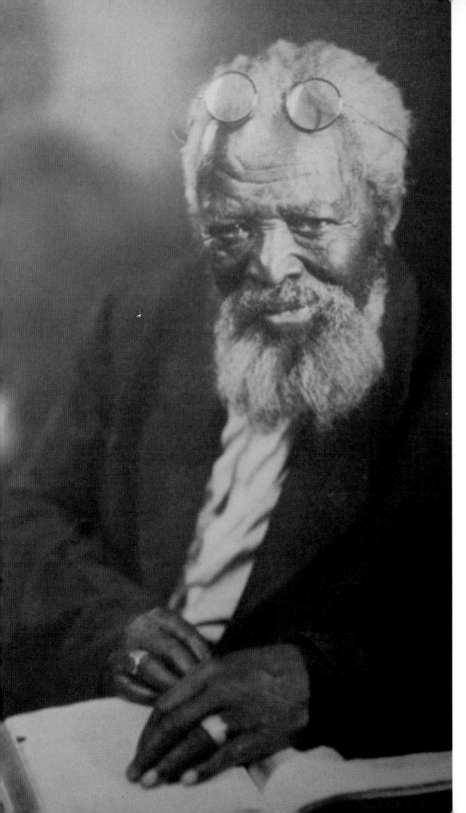

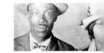

We are not a people of
 yesterday.
They ask how many seasons
 we have flowed
from our beginnings till
 now?
We shall point them to the
 proper beginnings of
 their counting.
On a clear night when the
 light of the moon has
blighted the ancient woman
 and her seven
children, on such a night,
 tell them to
go along into the world.
There, have them count first
 the one, then the seven
and after the seven, all the
 other stars visible
to their eyes alone.

—AYI KWEI ARMAH

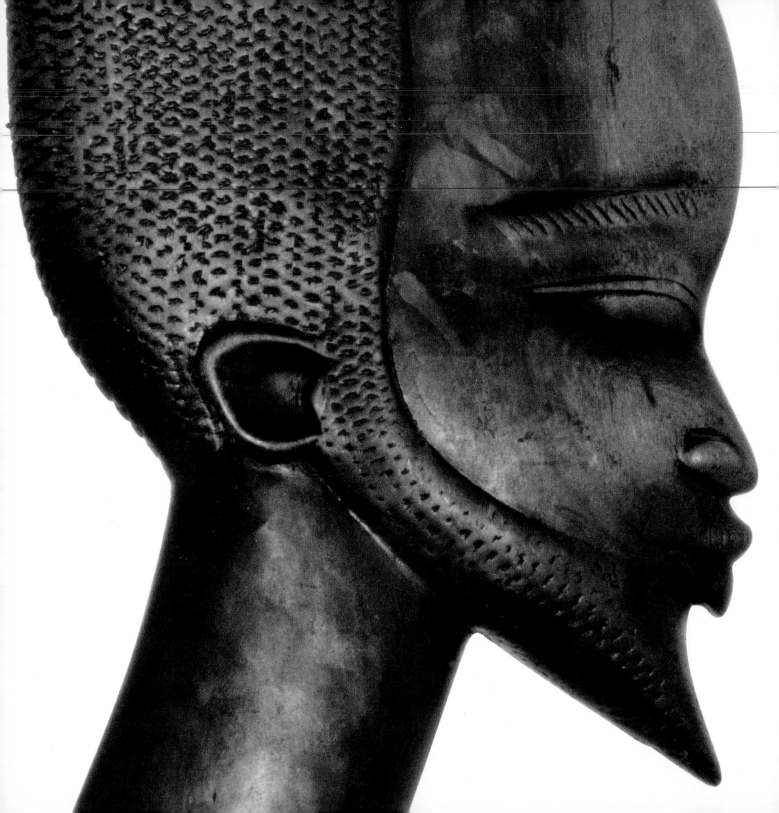

I AM HUMAN

What do you mean "What am I?"

No, I mean "What *are* you?"

I am **HUMAN**.

No, I mean what nationality?

I'm AMERICAN.

—MAYNARD JACKSON

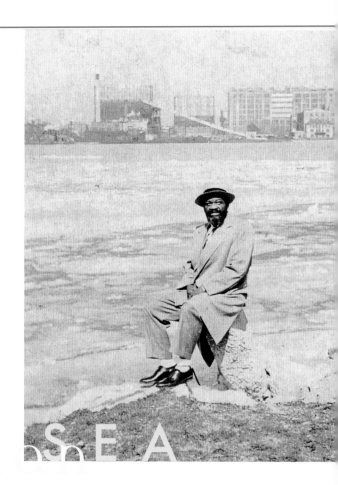

Throw a lucky man into the sea,

and he will come up

with a mouth full of fish.

—Arabic

I AM HUMAN

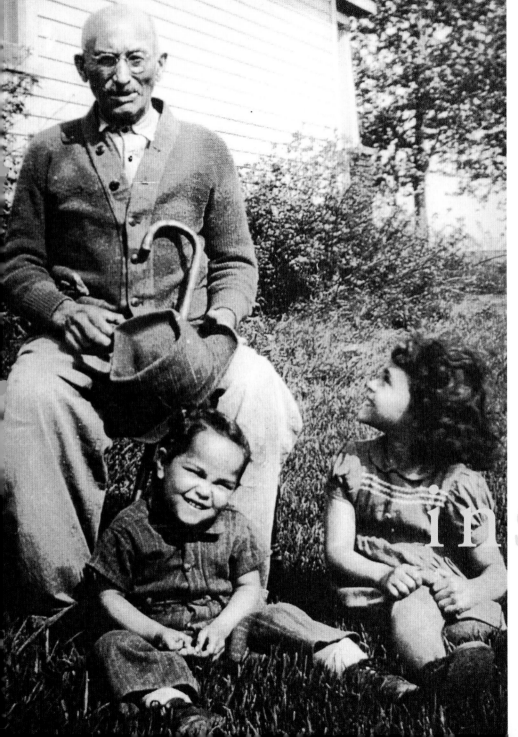

We must cherish our old
men.
We must revere their
wisdom,
appreciate their insight,
love the humanity
of their words.

— ALICE WALKER

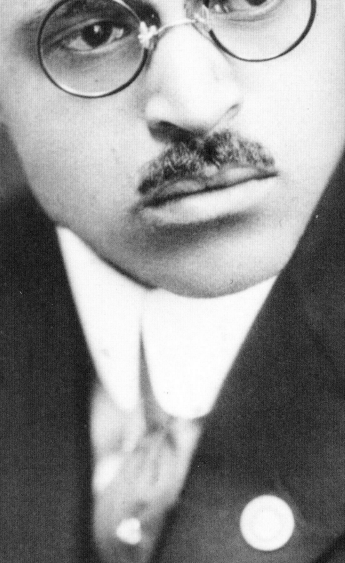

We are the new people.

Born of elevated rock

and lifted branches.

Called

Americans,

Not to mouth the label

but to live the reality,

Not to stop anywhere,

to respond to man,

to outgrow

each wider

limitation.

—JEAN TOOMER

30

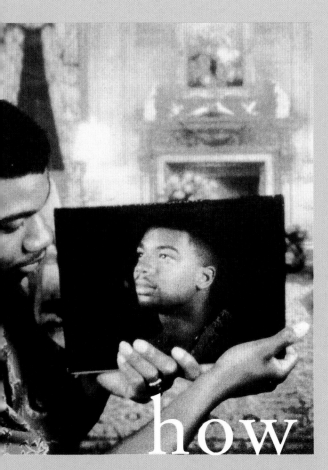

Martino

*Father, how sharp you stand
in the mirror.
I see myself.
Your praise and love—something
any son weeps for—
overtake me.*

—LENARD D. MOORE

how sharp you stand

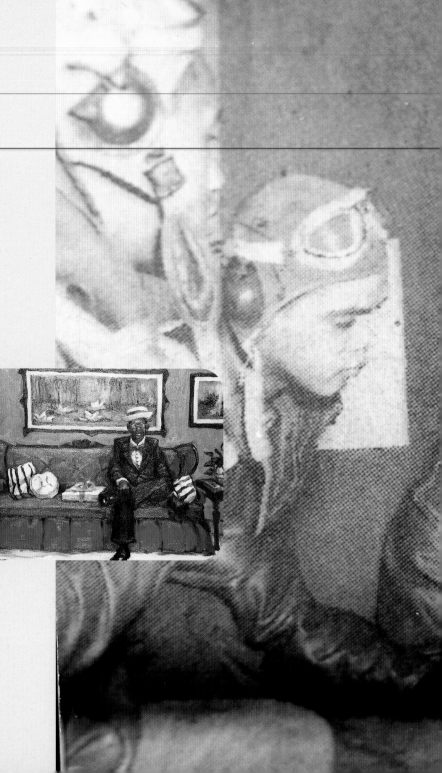

Opposite: *Tuskegee Airmen*

Donald Calloway, *Mr. Calloway*

I had learned many English words and could recite part of the Ten Commandments. I knew how to sleep on a bed, pray to Jesus, comb my hair, eat with a knife and fork, and use a toilet. I had also learned that a person thinks with his head instead of his heart.

—SUN CHIEF

I AM HUMAN

Don't ignore my color,

don't ignore my kinky hair,

don't ignore my somewhat flat nose.

I am a black person and

I don't want anyone to forget it!

Knowing the glory from whence I come,

I embrace my hue

like a warm quilt on a chilly evening.

—COLIN POWELL

Opposite: Donald Calloway, *Self-Portrait*

Of all the circumstances which predict a man's life and fortune, the single most important is the circumstance of birth, defined not by wealth or poverty, aristocracy or serfdom, or by color, but by the nature of a human being's first brush with humanity.

—Whitney Young

I AM HUMAN

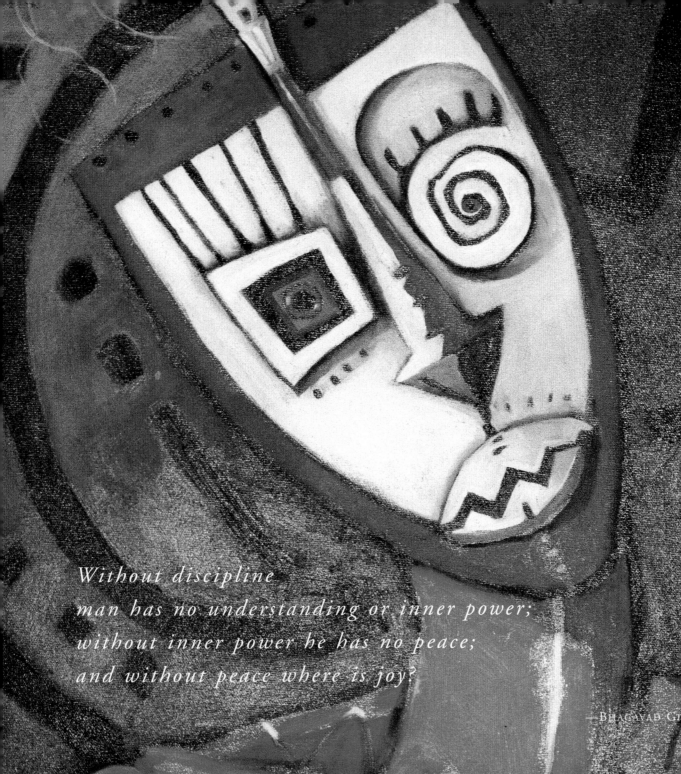

Without discipline
man has no understanding or inner power;
without inner power he has no peace;
and without peace where is joy?

—Bhagavad Gita

ROSELAND PARK CEMETERY ASSOCIATION

5981 WOODWARD AVENUE

DETROIT, MICH.

April 23, 1930.

Mr. Charles R. Webb,
 and
Mr. William C. Osby,
3764 Brush St.,
Detroit, Michigan.

Gentlemen -

 Your letter of April 7th addressed
to our President has been handed to me for reply. We
have sections in our Cemetery in which colored people,
and the white people who desire, may be buried. Un-
fortunately, in this community, and almost everywhere in
the United States, there is a violent and unreasonable
prejudice against the colored people. However, we have
already sold a large number of lots in the Cemetery at high
prices to the white people and expect to sell many more
to that same class, many of whom feel prejudice and feel
it most violently, and we in turn have to respect their
feelings.

 This Cemetery did set aside portions
of the Cemetery, as I have said before, in which negroes
would be received. A special entrance was erected for
the convenience of all owners of lots in Sections 21,
27 A-B-and C, 33, 37 and 39. To reach these sections
when the Woodward Ave. Entrance is used it is necessary to
traverse the entire length of the Cemetery. When few
people and few funerals were coming to Roseland this did
not make as much difference as it does now. The Board of
Directors agreed on this policy of entering the above
mentioned sections and they are certain to carry out that
plan.

 Our Entrance on the Twelve Mile Road is
convenient and the pavement much more comfortable to
traverse than going the full length of the Cemetery. The
fence along the Twelve Mile Road is perhaps not as nice as
along Woodward Ave. and the gateway not as handsome. How-
ever it is a public entrance and in due time we will have
an ornamental one there too. The Entrance cannot be called
a side entrance, nor a back entrance.

#2.

 When these lots were sold to you people, as
you know, there was no doubling of price or putting on a
lot of extra restrictions, but they were sold according
to our rules and regulations and under the same terms
of payment as to anyone else. We feel that our Board has
in every way tried to do the right thing by your race.
The Board is very sorry if you cannot see this matter in
the proper way and the necessity for our operating as we do.

 Yours very truly,

 ROSELAND PARK CEMETERY ASSOCIATION,

 Per Anne C McCarthy -
 Secretary.

William Osby

37

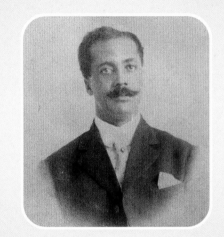

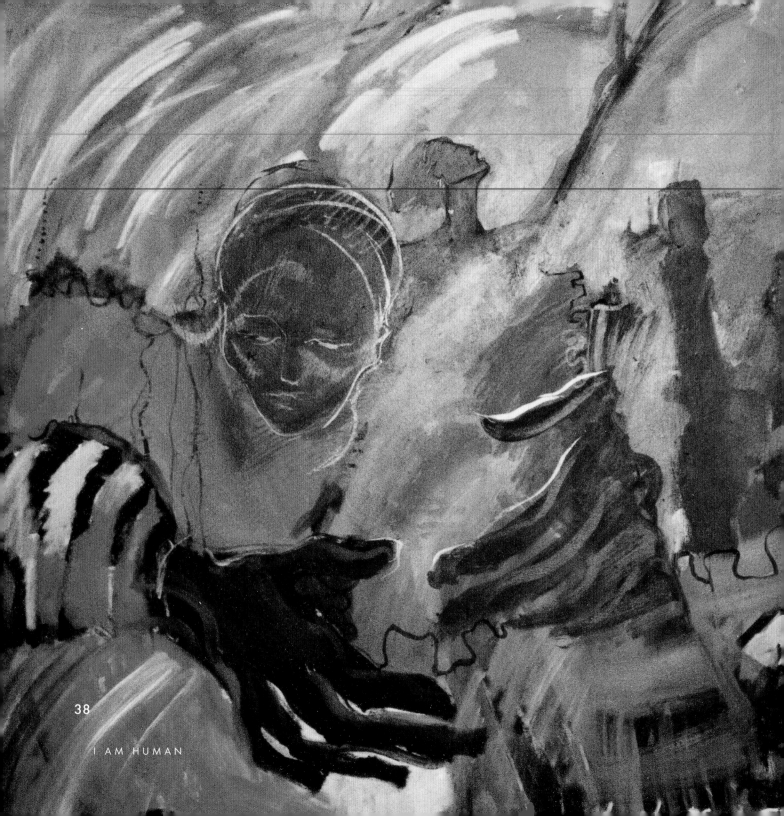

38

*Let no man of us budge
one step, and let slave-
holders come to beat us
from our country,
America is our country.
The greatest riches in all
America have arisen from
our blood and tears—
and will they drive us
from our property and
homes, which we have
earned with our blood?*

—David Walker

Brenda Dendy Stroud, *Cry of Anguish*

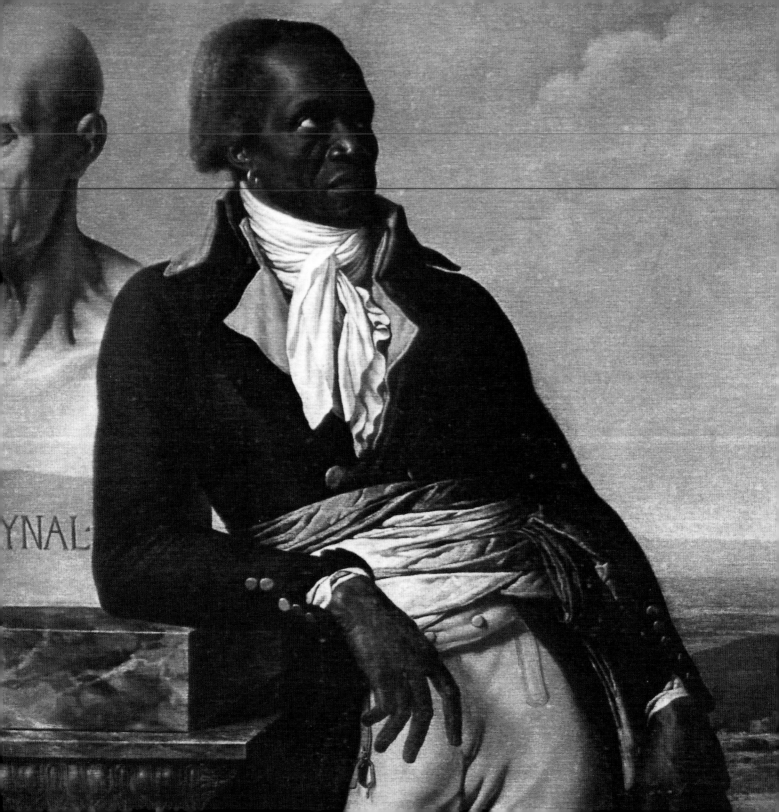

IF THERE IS NO STRUGGLE

If there is no STRUGgLE, there is no *progress.* Those who profess to favor freedom, and yet deprecate agitation, are men who want crops without plowing up the ground. They want rain without thunder and lightning. They want the ocean without the awful roar of its many waters. This struggle may be a *moral* one, or it may be *physical;* but it must be a struggle. Power concedes nothing **WITHOUT A DEMAND.** It never did and it never will.

—FREDERICK DOUGLASS

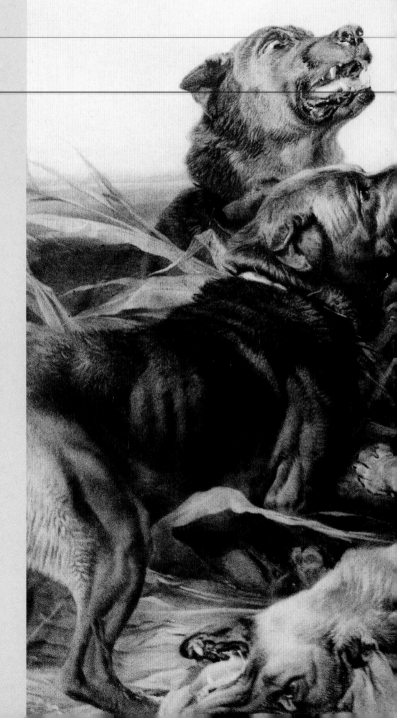

Richard Ausdell, *Hunted Slave*

Birth does not differ from birth;

as the free man was born

so was the slave.

—AFRICA

42

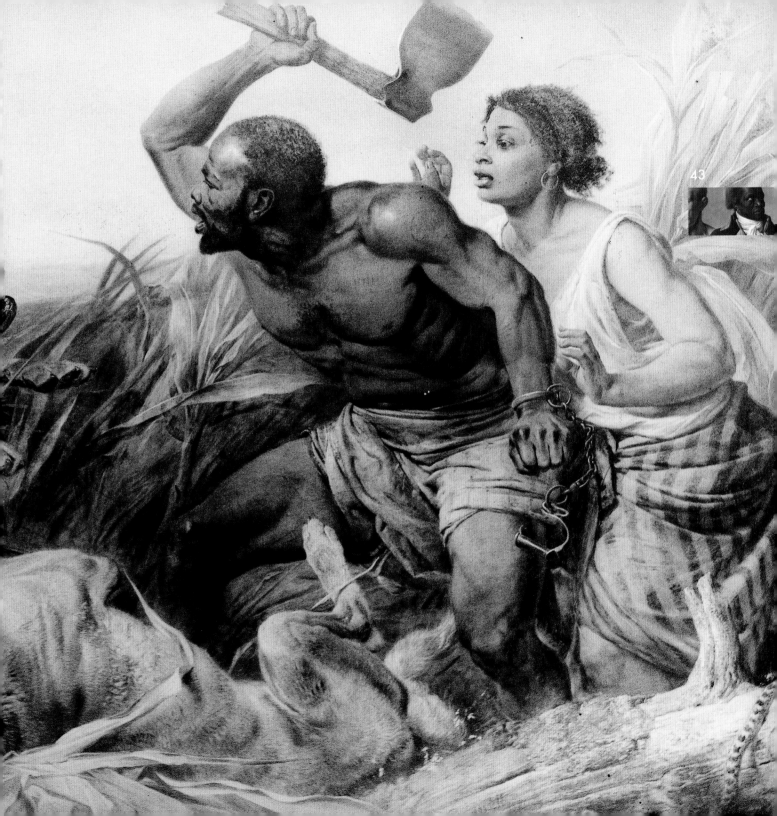

43

This creature, man, shall derive his power from the struggle of incomplete power which alone will rouse his mind with the appetite of wisdom.

—Mazisi Kunene

WISDOM

Being a man of colour,

I want only one thing: that instruments

never dominate people.

That the bondage of man by man stop.

—Franz Fanon

man of colour

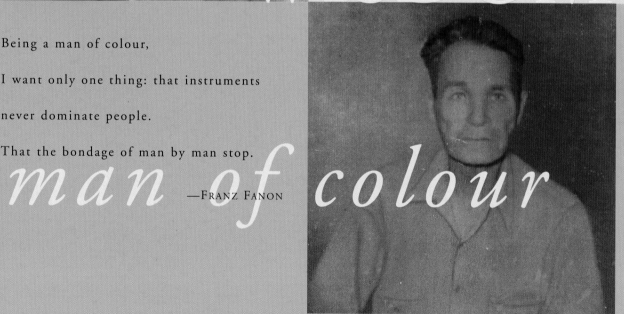

44

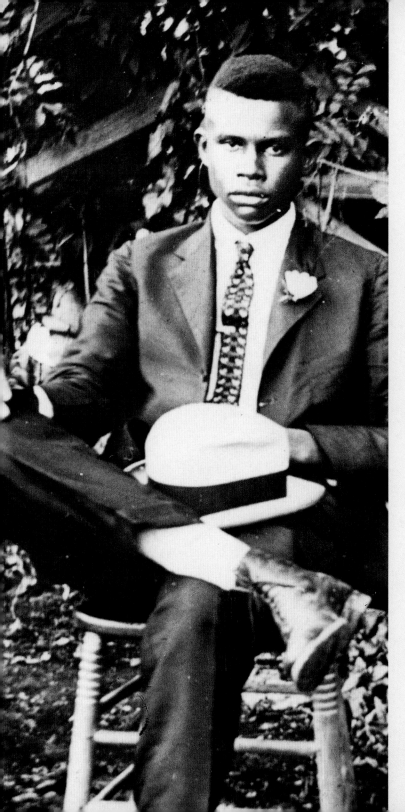

Opposite top: *Uncle Andrew,*
Mississippi

Opposite bottom: *Mr. Thompson,*
Homer, Louisiana

God has blessed me with this
ability, put me in a position to
make these leaps and bounds,
and I'm just trying to fulfill my
part of the bargain, which is to
give back, to be a positive
influence on others.

—DENZEL WASHINGTON

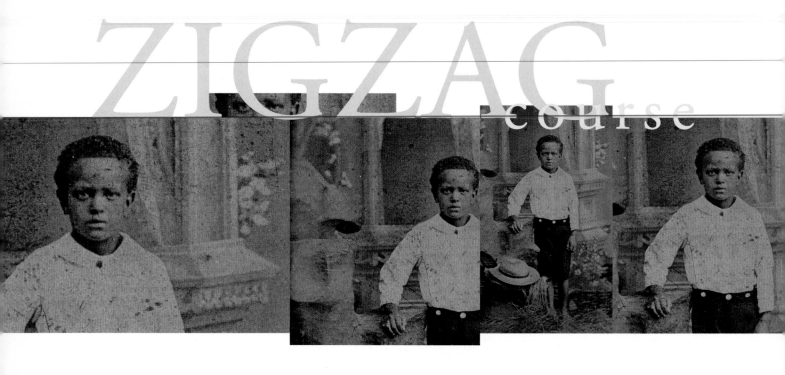

ZIGZAG course

*I see that the path of progress has never taken a
straight line, but has always been a zigzag course amid
the conflicting forces of right and wrong, truth and error,
justice and injustice, cruelty and mercy.*

—KELLY MILLER

46

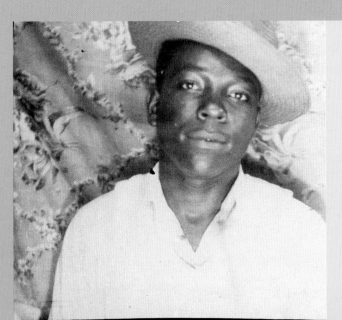

you are in his work, so you need not fear men's scorn. If they listen to your requests and grant them, you will be satisfied. If they reject them, then you must make their rejection your strength.

—MOHANDAS GANDHI

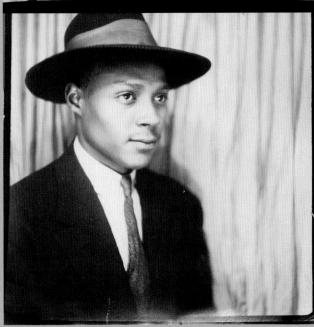

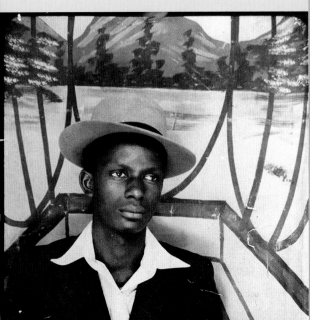

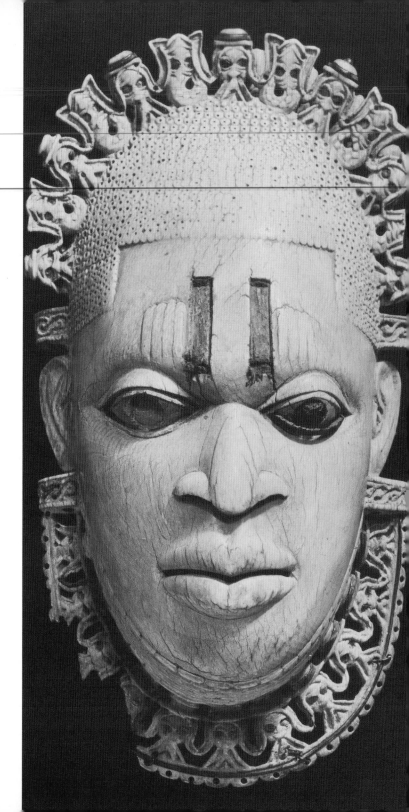

Benin Ivory Belt Mask, Nigeria

Opposite: Jamal Jones, *By Any Means Necessary*

Why do you take
by force
what you may have quietly
by love?

—POWHATAN

48

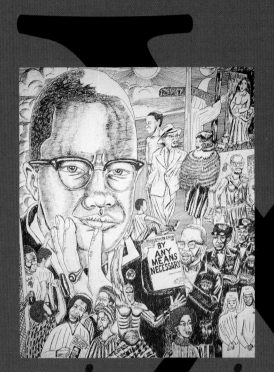

X *justice* FREEDOM

nobody can give you freedom.
nobody can give you equality
or justice
or anything.
if you're a man, you take it.

—Malcolm X

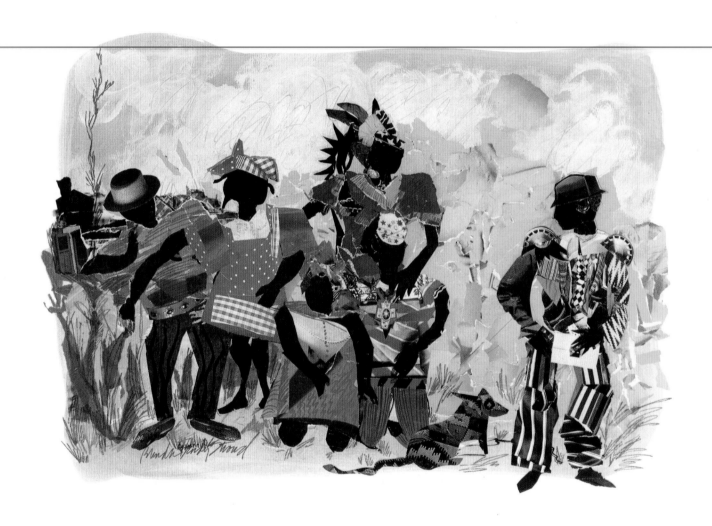

50

IF THERE IS NO STRUGGLE

God protects me when I travel.

I WALK WITH GOD.

—Laurence Fishburne

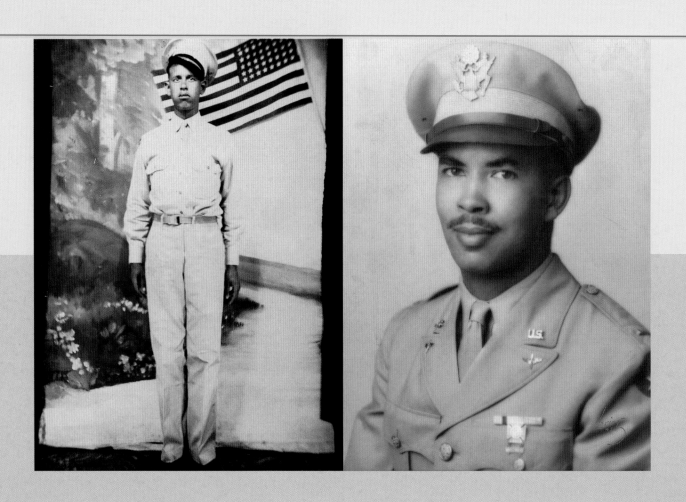

52

While the devotion, the gallantry, and the heroism displayed by our sons, brothers, and fathers at Port Hudson, Fort Wagner, Petersburg, New Market Heights are fresh in the minds of the American people, let us spare no pains, let us not fail to make every effort in our power to secure for ourselves and our children all those rights, natural and political, which belong to us as men and native-born citizens of America. . . . Shall they return, after weary months and years of laborious service, as soldiers and sailors, bearing the scars of hard-earned victories, to tread again the old way of degradation and wrong? It must not be.

—JOHN MERCER LANGSTON

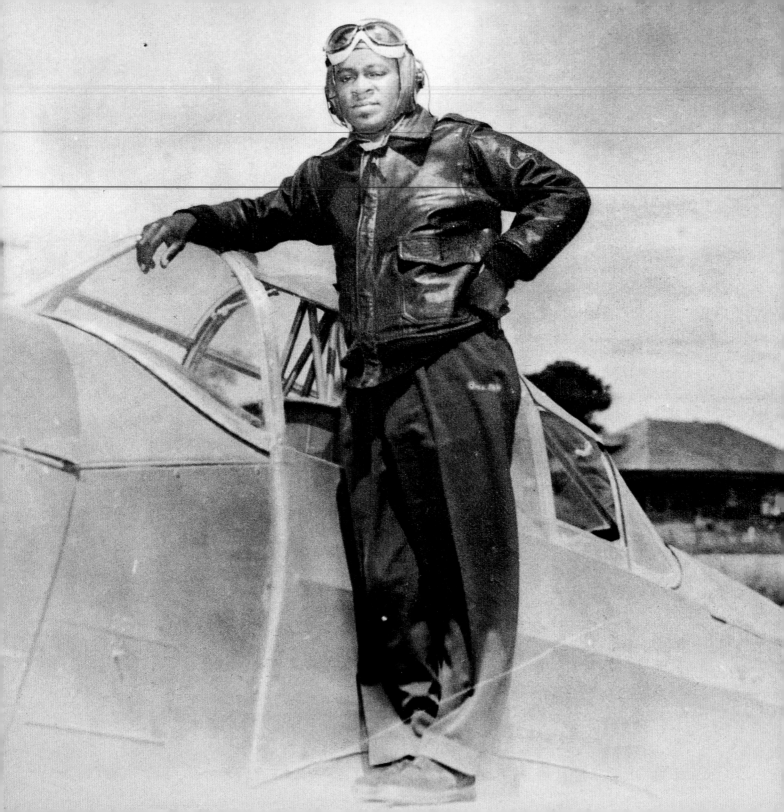

Dr. Dewitt A. Buckingham with His Plane, c. 1946

STRETCH YOUR WINGS

Whether or not you reach your *goals* in life depends entirely on how well you prepare for them and how badly you want them. **YOU'RE EAGLES!** Stretch your **wings** and F L Y to the sky.

—RONALD MCNAIR

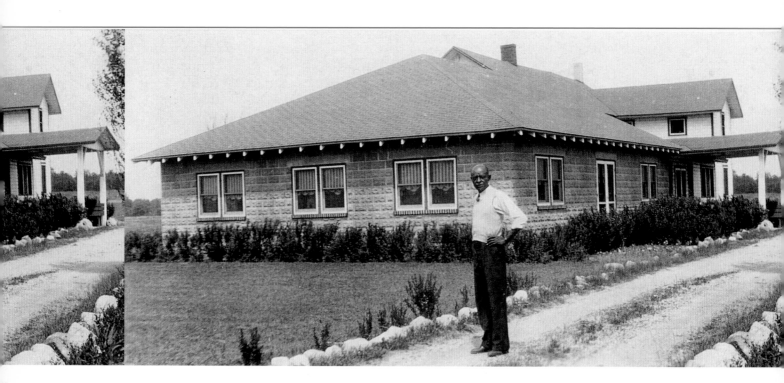

SOME MEN CAN BUILD HOUSES
IN THEIR HEADS.

—CONGO

56

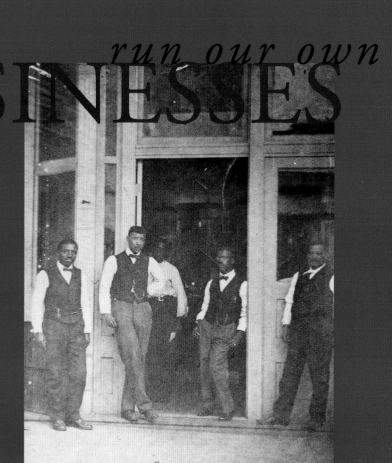

WE NEED TO RUN OUR OWN BUSINESSES

MORE, AND WE NEED TO RUN THEM THE

WAY DU BOIS RAN NIAGARA, THE WAY

HEALY RAN GEORGETOWN, THE WAY

JOHNSON RAN JET, THE WAY GASTON RAN

PART OF BIRMINGHAM, THE WAY GORDY RAN

MOTOWN, THE WAY REGGIE LEWIS RAN

BEATRICE.

—RALPH WILEY

run our own
BUSINESSES

Duke Ellington never grinned. He smiled. sat up high

Ellington never shuffled. He strode.

It was "Good afternoon, ladies and gentlemen,"

never "How y'all doin'?" At his performances we

sat up high in our seats.

—GORDON PARKS

58

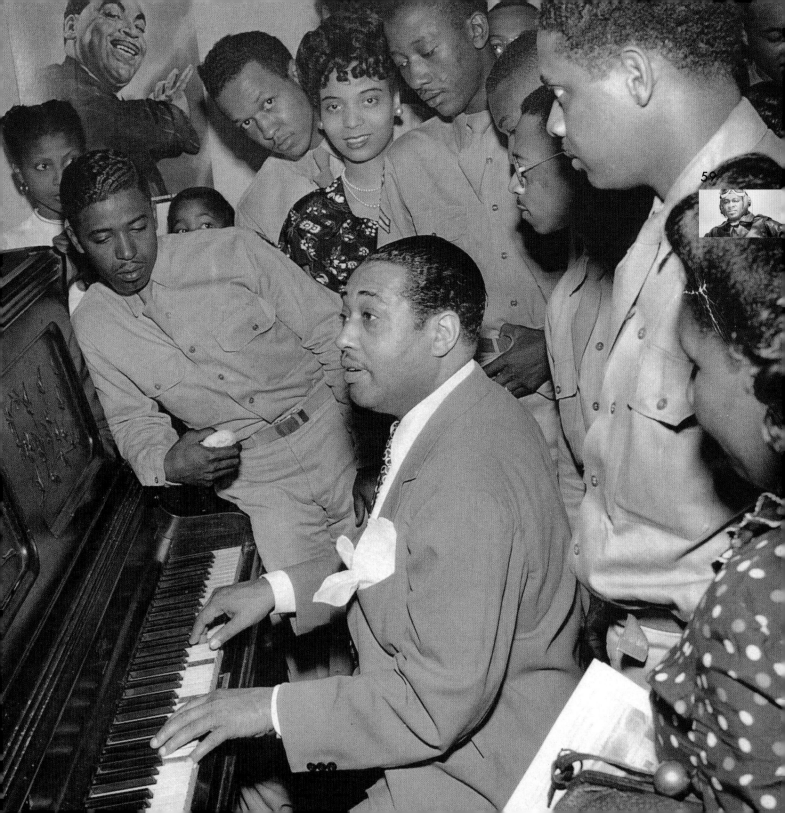
59

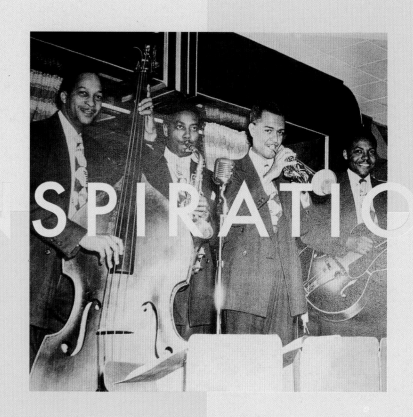

INSPIRATION

STRETCH YOUR WINGS

INSPIRATION

whenever i need inspiration i listen to people

like Duke Ellington, charlie parker,

and miles Davis. My goal is to be like them.

—Wynton Marsalis

Malvin G. Johnson, *Elks Marching*

perfect his talents

& potentials

The injustices imposed upon the black man for centuries make it all the more obligatory that he develop himself. . . . There must be no dichotomy between the development of one's mind and a deep sense of appreciation of one's heritage. . . . The dice are loaded against him. Knowing this as the Jew knows about anti-Semitism, the black man must never forget the necessity that he perfect his talents and potentials to the ultimate.

—BENJAMIN MAYS

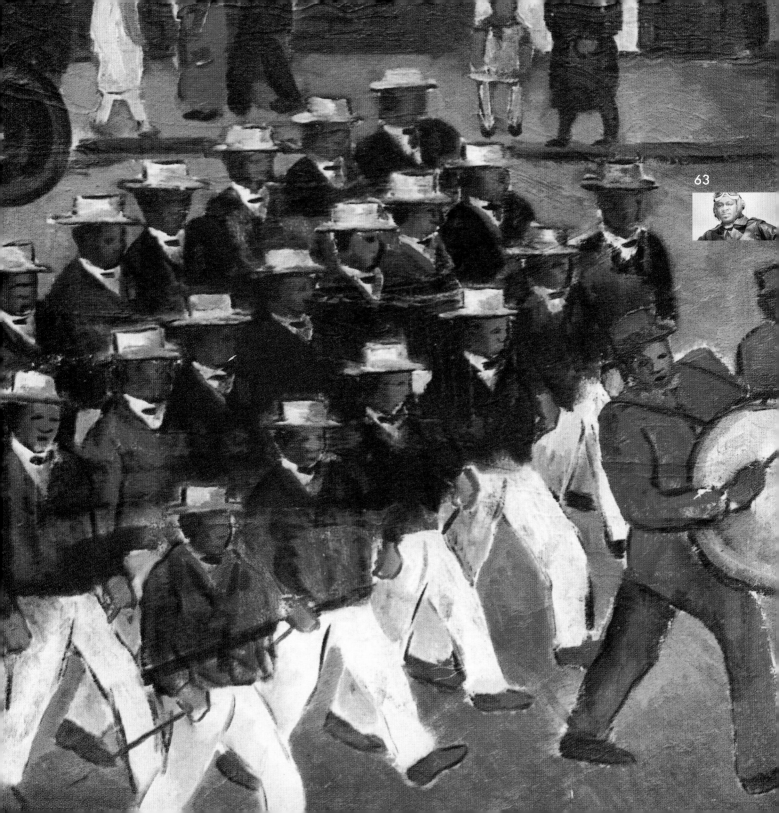

There are no secrets to success: Don't waste time looking for them. Success is the result of perfection, hard work, learning from failure, loyalty to those for whom you work, and persistence.

—COLIN POWELL

no secrets to SUCCESS

65

see clearly

foundation

Our lives are spread before us. As we look at them, there is much that we do not recognize as belonging to us. There are those things which we see clearly and distinctly for the first time. We see how the outer edges of our lives touch the outer edges of others. We sense a deeper sense of relationship which

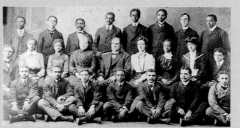

gives us the reassurance and strength we gather from those who walk the way with us. All the predicaments, problems, and issues of our lives pile in upon us and we seek some clue by which all of the things that involve us may fall into place and make sense to our minds and spirits. We grapple with our hungers and desires with the fears and frustrations and over-riding anxieties with which we face tomorrow. We hope that some quality of stillness will invade us, that the foundation of our lives may become more secure, and the steps we may take be more certain and more fulfilling.

—HOWARD THURMAN

tomorrow

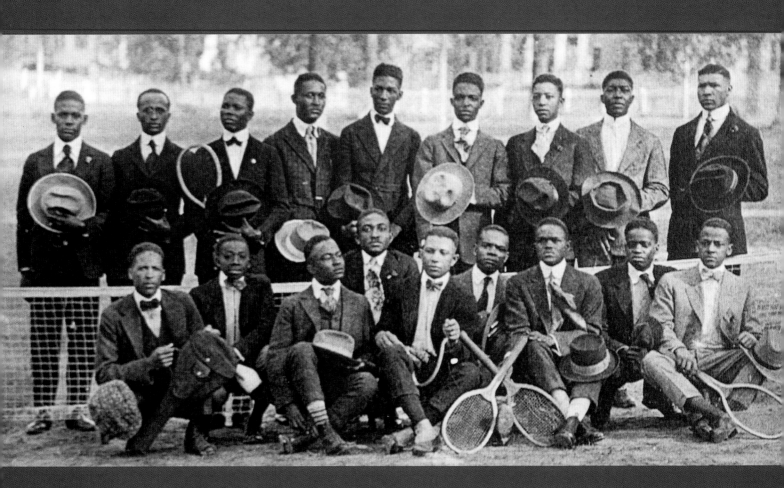

66

Our deepest fear is not that we are
 inadequate.
Our deepest fear is that we are powerful
 beyond measure.
It is our light, not our darkness, that
 most frightens us.
We ask ourselves, who am I to be
 brilliant, gorgeous, talented, and
 fabulous?
Actually, who are you not to be?
You are a child of God.
Your playing small doesn't serve the
 world.
There's nothing enlightened about
 shrinking so that other people won't
 feel insecure around you.
You were born to make manifest the
 glory of God that is within us.
It's not just in some of us, it's in
 everyone.
And as we let our light shine, we
 unconsciously give other people
 permission to do the same.
As we are liberated from our own fear,
 our presence automatically
liberates others.

—NELSON MANDELA

Alcorn College Glee Club, 1918

child of god

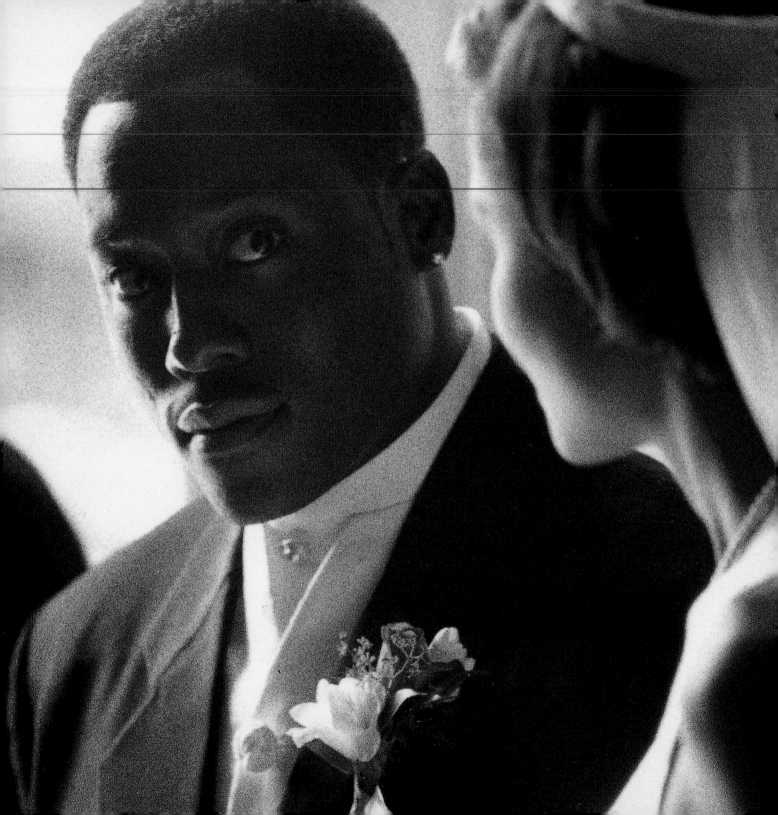

ONLY THAT YOU LOVE

Life
does not question who you *love*,
or even how you *love* . . . only THAT YOU LOVE.

—GEORGE NORMAN

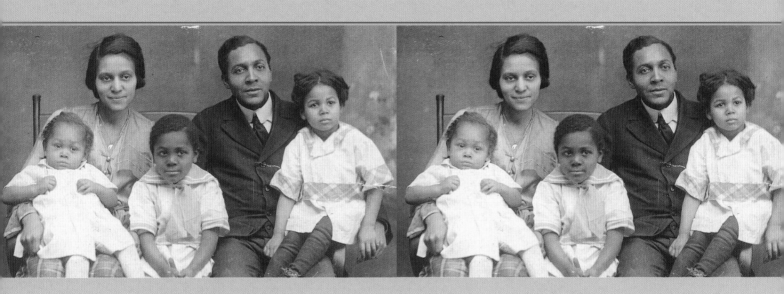

All people are leaders,
each individual must ultimately
be a leader himself.

—JOHN HENRIK CLARKE

70

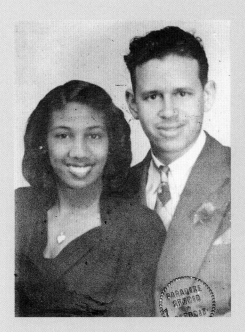

Life suddenly widened its horizons and took on new meaning. I knew clearly just how lonely I had become, just how badly I needed someone, rather than just something to cling to, someone to work for, rather than a goal to aim for, someone to dream with, cherish from day to day, and share the little things with, the smiles and if need be the tears that will sometimes come.

—CHARLES RICHARD DREW

Tell me whom you love and I'll

tell you who you are.

—CREOLE PROVERB

ONLY THAT YOU LOVE

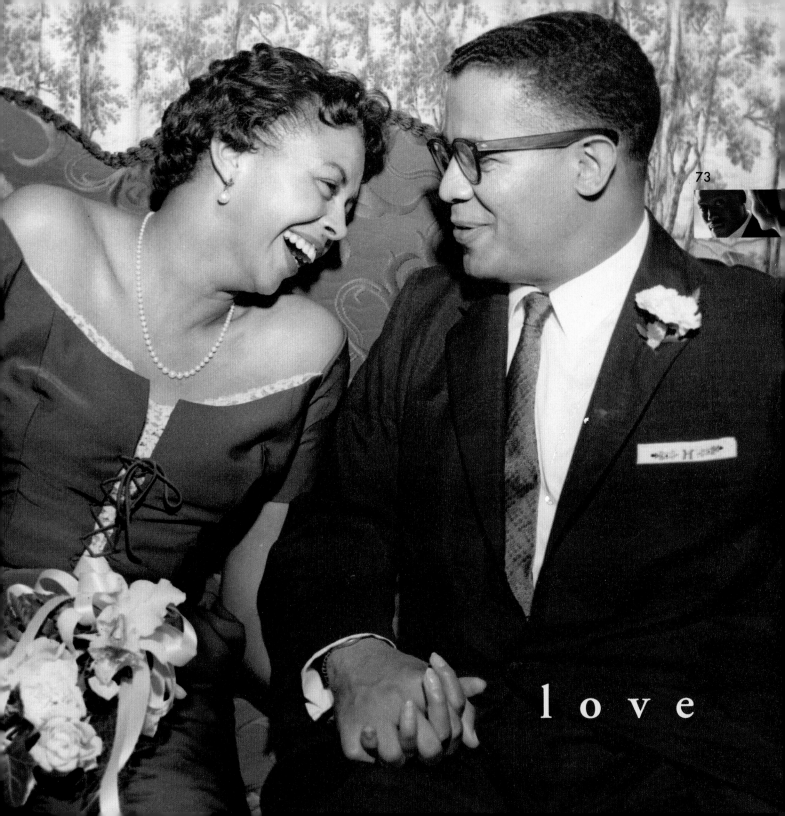

love

Donald Calloway, *African Mask*

I'M THE WORLD CHAMPION BUT I DON'T FEEL ANY DIFFERENT THAN

THE FAN OVER THERE. I'LL STILL WALK IN THE GHETTOES, ANSWER

NEVER FORGET MY

QUESTIONS, KISS BABIES. I DIDN'T MARRY A BLONDE OR GO NUDE

IN THE MOVIES. I'LL NEVER FORGET MY PEOPLE.

—MUHAMMAD ALI

PEOPLE

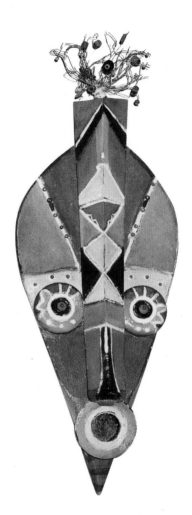

I could have loved better

but I couldn't have loved more.

—Calvin Forbes

76

ONLY THAT YOU LOVE

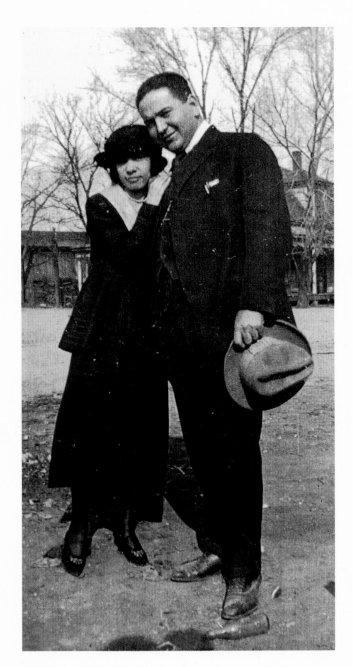

The moon, the circle moon

argued with me

. . . told me that I could

gather up all the dust of

the circle night

and I could tell you

woman

I love you.

—HENRY DUMAS

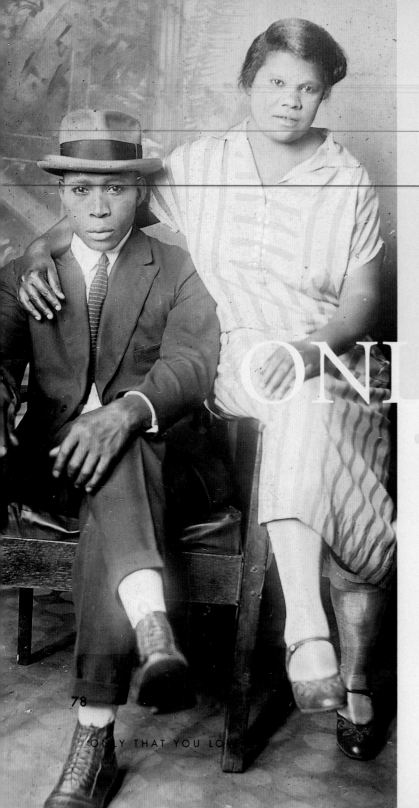

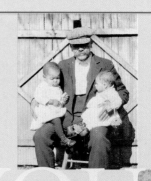

ONLY YOU

I
have loved only you, surrendered my whole
self reckless to you and nobody else. I
want you to love me back and show it
to me. I love the way you hold me,
how close you let me be to you.
I like your fingers on and on, lifting,
turning.
I have watched your face for a long time
now, and missed your eyes when you
went away from me.

—TONI MORRISON

ONLY THAT YOU LO

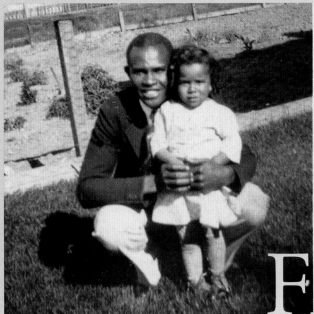

FATHER

FOR YOU ARE FATHER TO THE ORPHAN,

HUSBAND TO THE WIDOW,

BROTHER TO THE REJECTED WOMAN,

APRON TO THE MOTHERLESS.

—KHUN ANUP

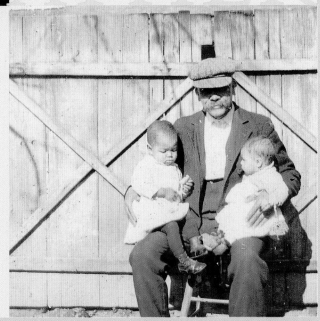

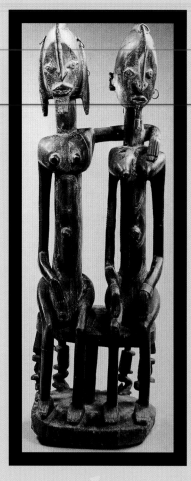

Mali

Opposite: Brenda Dendy Stroud,
 Challenge

The voice of the wild goose shrills,
It is caught by its bait:
My love of you pervades me,
I cannot loosen it.
I shall retrieve my nets,
But what do I tell my mother,
To whom I go daily,
laden with bird catch?
I have spread no snares today,
I am caught in my love of you.

—PAPYRUS HARRIS

caught IN LOVE

ONLY THAT YOU LOVE

Again and again we are baffled by the confusion which we experience when we try to make clear to another what it is that our hearts would say and our minds would think. We want to be understood, to be sure that the word will be tenderly held and that the mood which is our mood will be deeply and profoundly shared. Again and again this is not our experience. We turn our eyes sometimes outward, casting a spell of judgments upon the words of others, the deeds of others, the moods of others. Sometimes when we are most ourselves, the eye turns inward and we are surprised to discover that what we did share was what we intended to share, that the searching honesty of our own hearts is something which we ourselves are not acquainted. This is our experience with ourselves and each other.

—HOWARD THURMAN

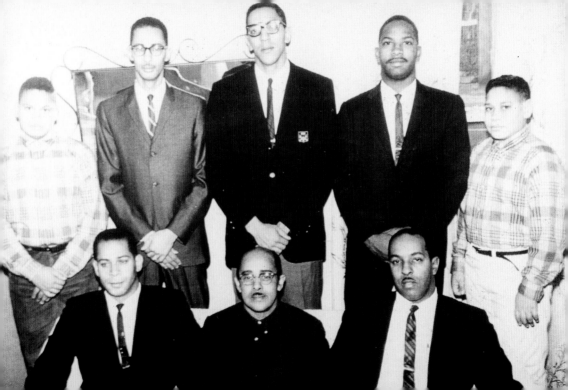

I respect you

for all your accomplishments

and your inner persistent strength.

I admire you

for your dynamic spirit

and your versatile personality.

I trust you,

for all my life you have been there

no matter the time, the day, or the season.

I need you

for your loving lessons taught

through our honest conversations.

I enjoy you

as a strong man, not just as a big brother;

yours is great company to keep.

I applaud you

for your compassion and concern

in helping others.

I love you

for all the love and sacrifices

you have made and given

to me!

—TIAUDRA RILEY

Big Brother

Father with Seven Sons

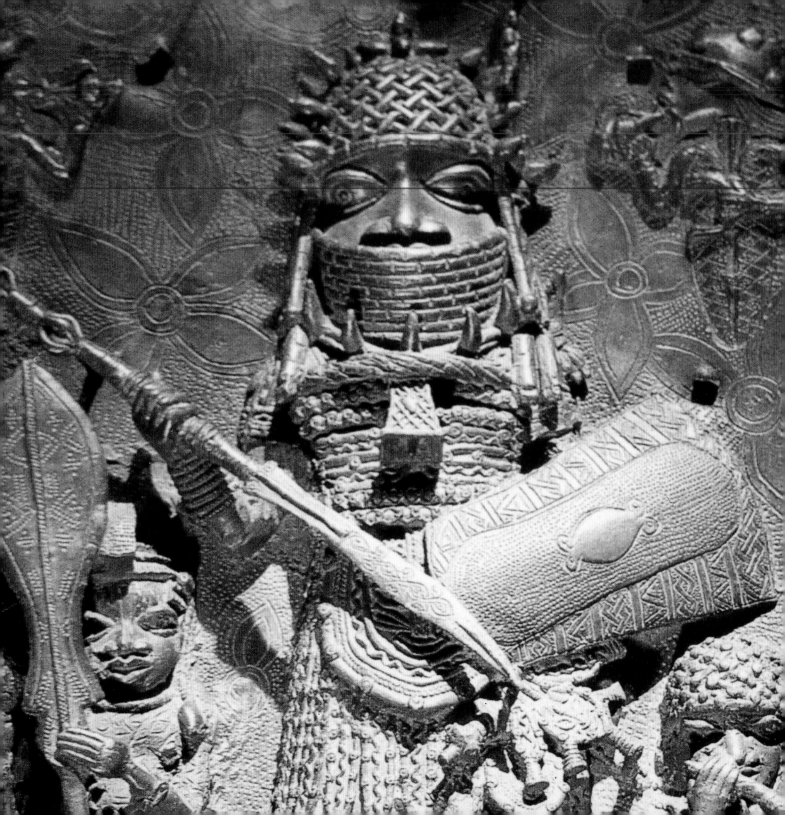

LEADERSHIP—
THE SKILL AND THE WILL

CHAMPIONS are made from something they have deep inside them—*a desire, a dream, a vision*. They have to have last-minute stamina, they have be a little faster, they have to have the **SKILL AND THE WILL**. But the will must be stronger than the skill.

—MUHAMMAD ALI

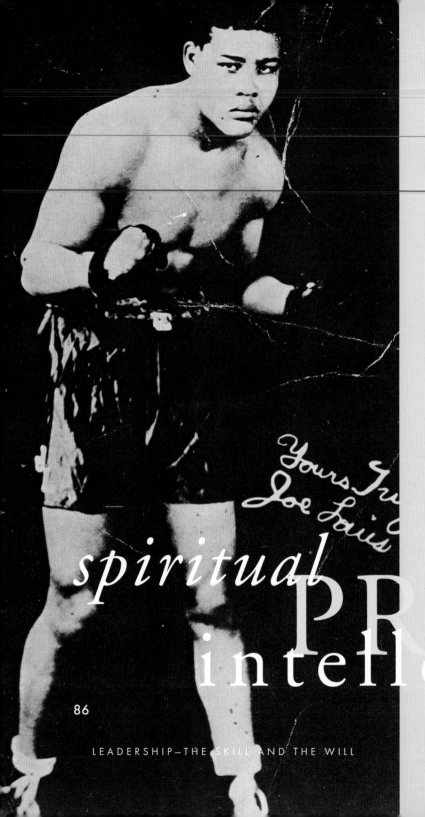

Yours Tr Joe Louis

spiritual

PRAYER

intellect

LEADERSHIP–THE SKILL AND THE WILL

Joe Louis

Opposite: *Detroit Mayor Dennis Archer, 1997*

Everything starts with the spiritual. To be the best you can be, you have to have the intellect. My body just does what my mind tells it to. Losers quit. When you have a sound mind, you can do what's necessary. I've been in this game twenty-six years and it's been prayer that has kept me focused.

—EVANDER HOLYFIELD

I am only one,

but I am one.

I cannot do everything

but I can do something.

What I can do, that I ought to do,

and what I ought to do, by the

grace of God

I will do.

i will do

—ADAM CLAYTON POWELL JR.

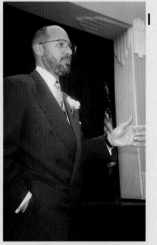

MAN

The successful man
will look for work
even after he has
found
a job.

successful

—Joshua I. Smith

LEADERSHIP—THE SKILL AND THE WILL

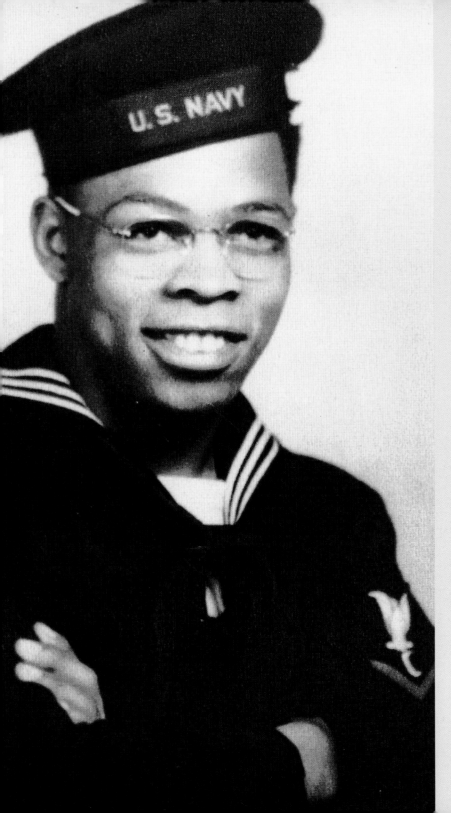

Who am I now?

What have I become?

Where do we draw the line

between being

who I am and what I ought to be?

—AL YOUNG

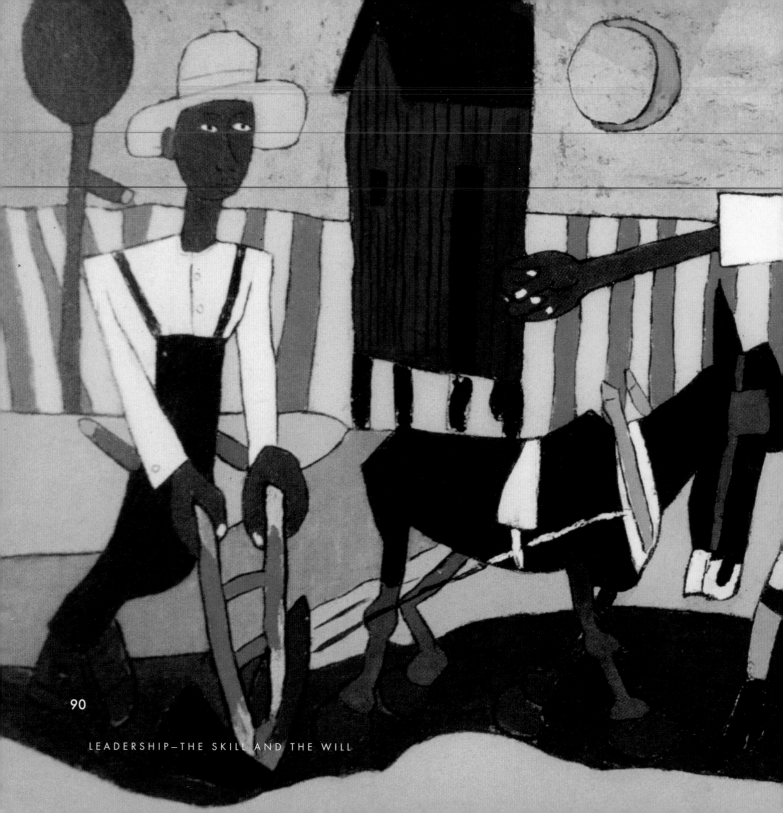

90

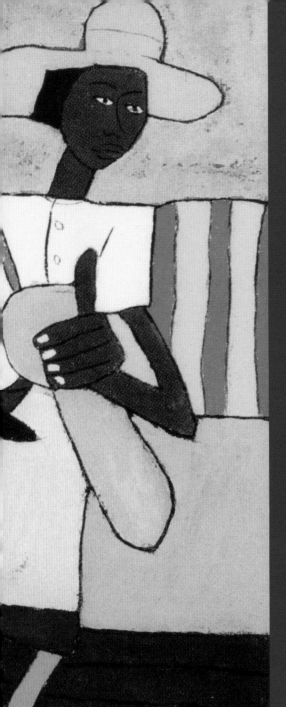

William H. Johnson, *Sowing*

The sweat from the brows of my ancestors

 has fallen

in rice fields,

cotton plantations,

railroad cuts,

in the forests,

and along the mountainsides.

In times of danger we have

answered every call and

spilled our blood

for American ideals whenever it was neces-

 sary to do so.

In this way I feel that we have

purchased the right

to equal citizenship and

all opportunities

that go along with it

under the law.

—JOHN WESLEY DOBBS

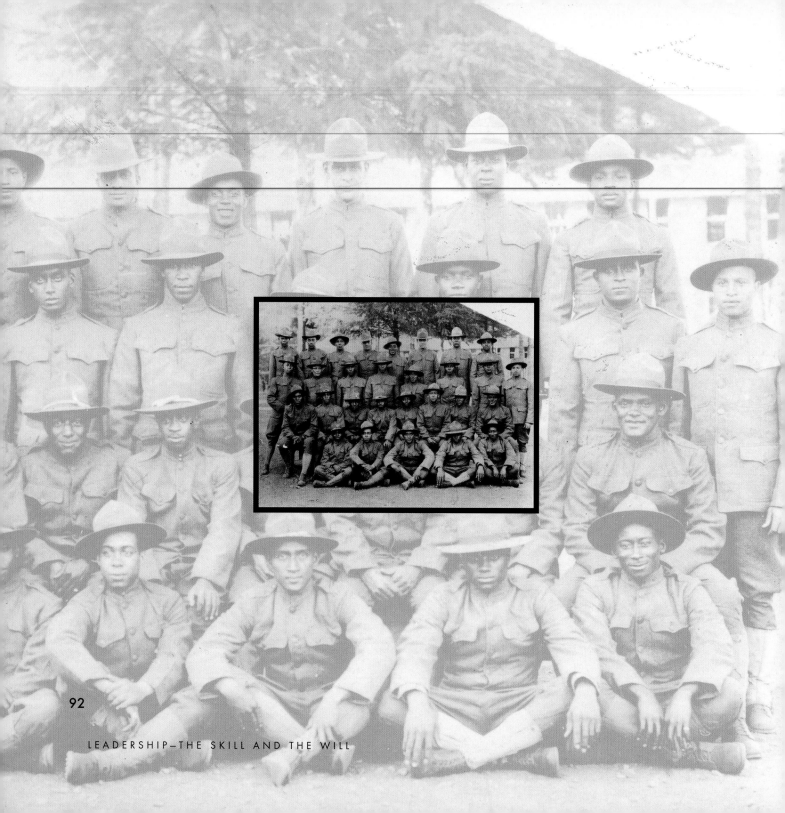

92

Camp Lewis, 1918

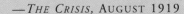

THE RETURNING COLORED SOLDIERS ARE A BIG FACTOR IN, AND BIG CON-

TRIBUTORS TO, THIS NEW NEGRO CONSCIOUSNESS. THEY RETURN WITH

HEADS UP, WITH A MORE ACUTE SENSE OF THE HARD CONDITIONS TO

WHICH THEY WERE BORN AND WITH A FRESH DETERMINATION, SINCE THEY

RIGHTLY HAVE BEEN MADE MUCH OF, TO MAKE SOMETHING OF THEM-

SELVES. THEY HAVE BEEN UNDER DISCIPLINE, AND THE EFFECT OF DISCI-

PLINE IS DUAL. IT BOTH TAMES AND MAKES A MAN.

—*THE CRISIS*, AUGUST 1919

discipline
determination
MAKES A MAN

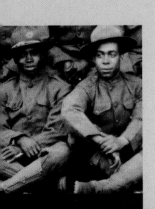

James Henry Buckingham, c. 1925

there are no wrong notes.

—Thelonious Monk

LEADERSHIP—THE SKILL AND THE WILL

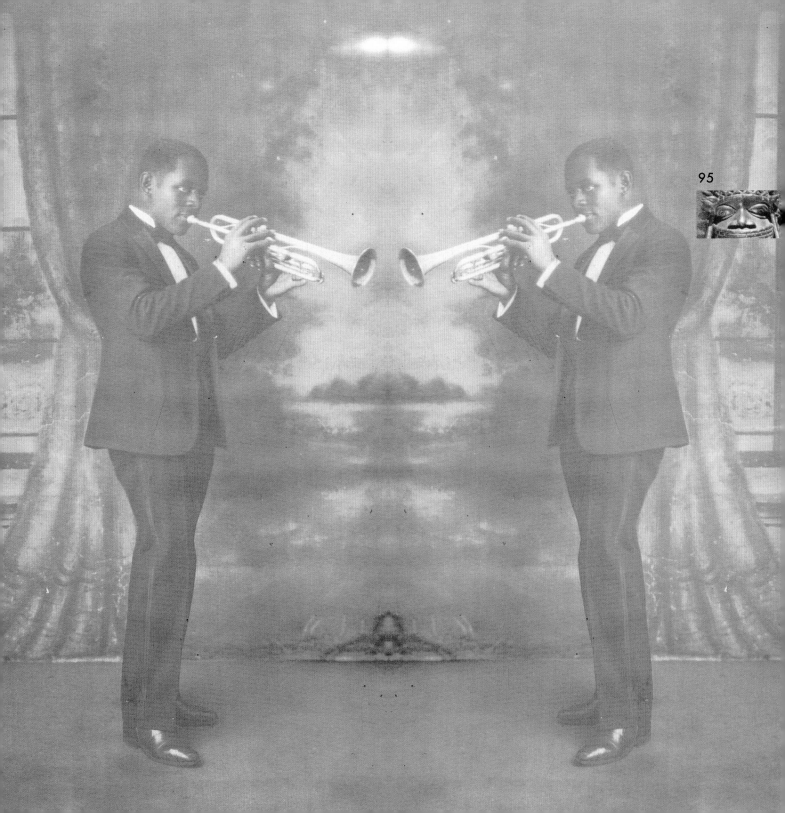

Jess Stahl on Grave Digger,
Pendleton Roundup

telling of heroes
great deeds

LEADERSHIP—THE SKILL AND THE WILL

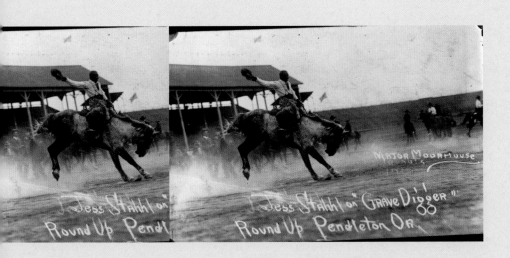

When I hear the old men
telling of heroes,
telling of great deeds
of ancient days.
When I hear them telling,
then I think within me
I, too, am one of these.

—CHIPPEWA

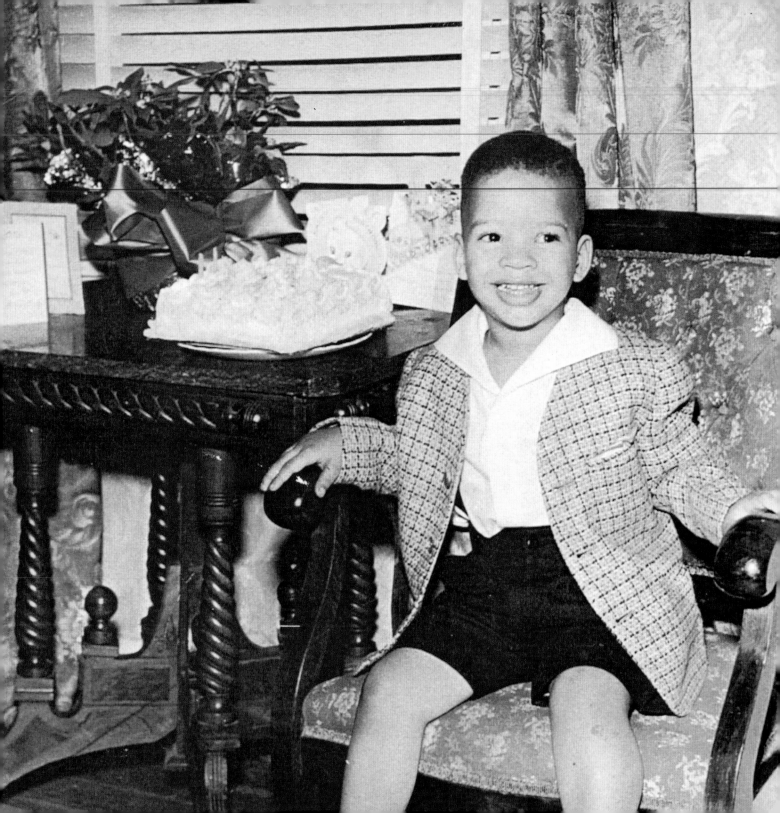

EVERY TOMORROW, A VISION OF HOPE

To return hate for HATE DOES NOTHING but intensify the existence of evil in the universe. Someone must have *sense* enough and *religion* enough to cut off the chain of hate and evil, and this can only be done through LOVE.

—Martin Luther King Jr.

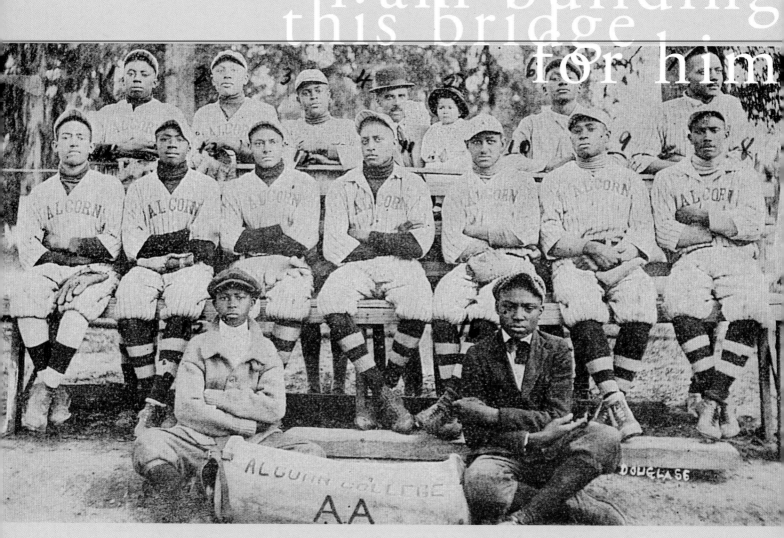

Alcorn College Baseball Team, 1918

i am building this bridge for him

EVERY TOMORROW, A VISION OF HOPE

THE BRIDGE BUILDER

CHASM *no fear for me*

An old man going a lone highway
Came at the evening cold and gray

To a chasm vast and deep and wide.
The old man crossed in the twilight dim:
The sullen stream had no fear for him
But he turned when safe on the other side
And built a bridge to span the tide.
"Old Man," said a pilgrim near,
"You are wasting your strength building here.
Your journey ends with the ending day;
You never again will cross this way.
You've crossed the chasm deep and wide,
Why do you build here at the evening tide?"
The builder raised his old grey head,
"Good friend, in the path I've come," he said,
"Here follows after me today,
A youth whose feet must pass this way;
The chasm that held no fear for me,
To this fair-haired youth may a pitfall be,
He too must cross in the twilight dim;
Good friend, I am building this bridge for him."

—BENJAMIN MAYS

PROMISE

man is a promise

that he must never break.

—Richard Wright

102

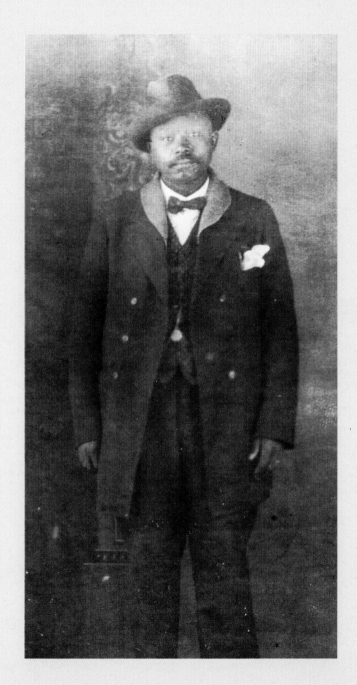

For every man, there is a necessity to establish as securely as possible the lines along which he proposes to live his life. In developing his life's working paper, he must take into account many factors, in his reaction to which he may seem to throw them out of line with their true significance. As a man, he did not happen. He was born, he has a name, he has forbears, he has a mother tongue, he belongs to a nation, he is born with some kind of faith. In addition to all these, he exists, in some curious way, as a person independent of all other facts. There is an intensely private world, all his own; it is intimate, exclusive, sealed. The life working paper of the individual is made up of a creative synthesis of what the man is in all his parts and how he reacts to the living processes. It is wide of the mark to say that a man's working paper is ever wrong; it may not be fruitful, it may be negative, but it is never wrong. For such a judgment would imply that the synthesis is guaranteed to be of a certain kind of a specific nature, resulting in a foreordained end. It can never be determined just what a man will fashion. Two men may be born of the same parents, grow up in the same environment, be steeped in the same culture and inspired by the same faith. Close or cursory observation may reveal that each has fashioned a life working paper so unique that different roads are taken. Or it may be that they move along precise parallel lines that never meet. Always, then there is the miracle of the working paper.

—HOWARD THURMAN

104

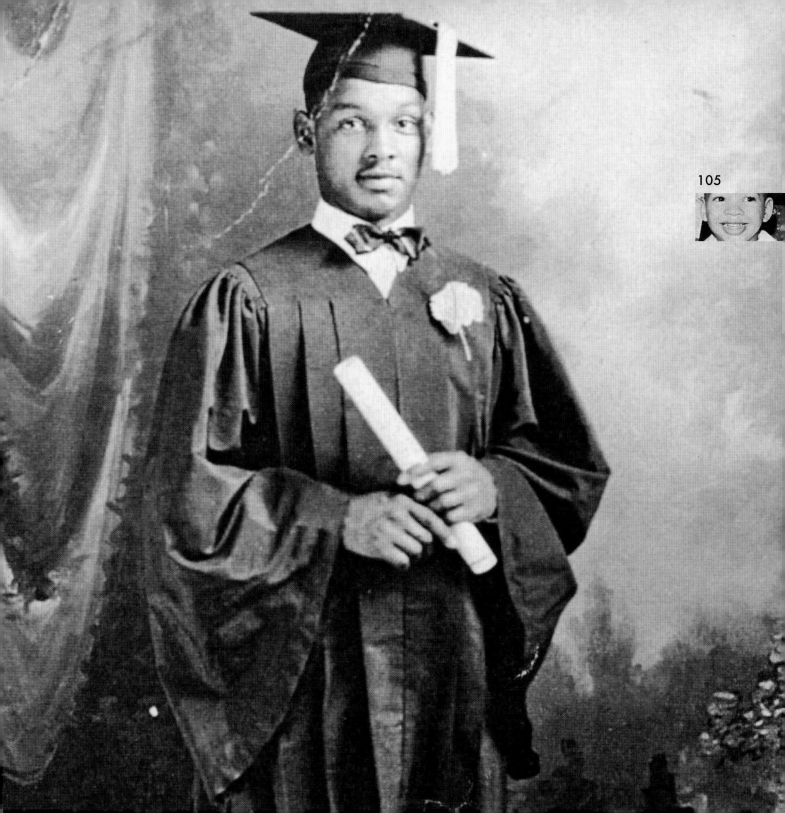

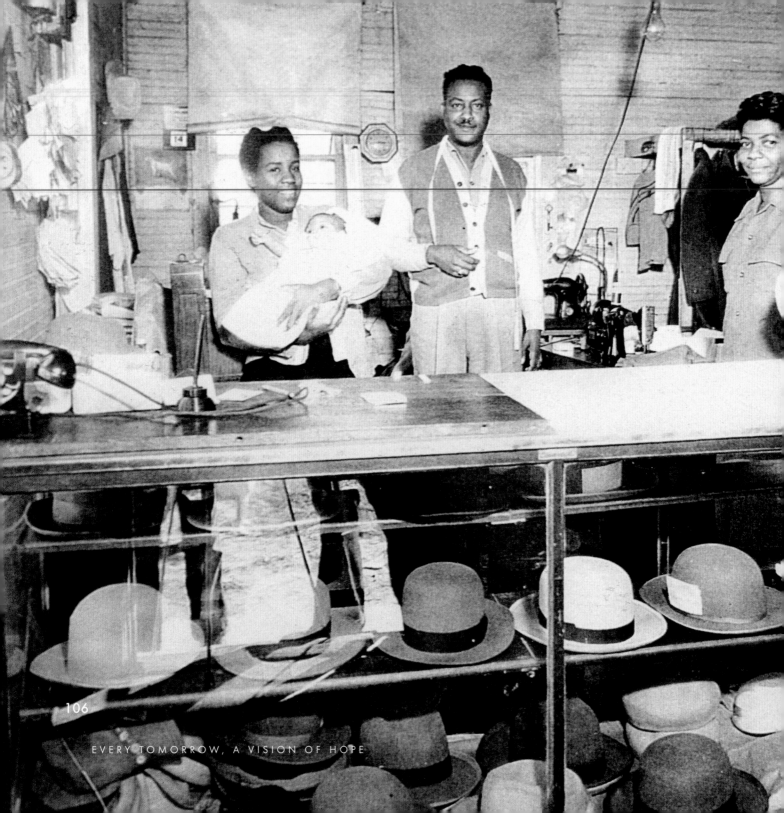

106

WHERE JUSTICE IS DENIED, WHERE POVERTY IS ENFORCED, WHERE IGNORANCE PREVAILS, AND WHERE ANY ONE CLASS IS MADE TO FEEL THAT SOCIETY IS IN AN ORGANIZED CONSPIRACY TO OPPRESS, ROB, AND DEGRADE THEM, NEITHER PERSON NOR PROPERTY WILL BE SAFE.

justice

—FREDERICK DOUGLASS

Ted Riley

Are you looking for me?

I am in the next seat.

My shoulder is against yours.

You will not find me in stupas,

not in Indian shrine rooms,

nor in synagogue,

nor in cathedrals;

Not in masses,

nor kirtans,

not in legs winding around your own neck,

not in eating nothing but vegetables.

When you really look for me,

you will see me instantly—

You will find me in the tiniest house of time.

—KABIR, 15TH CENTURY

are you looking
FOR ME

108

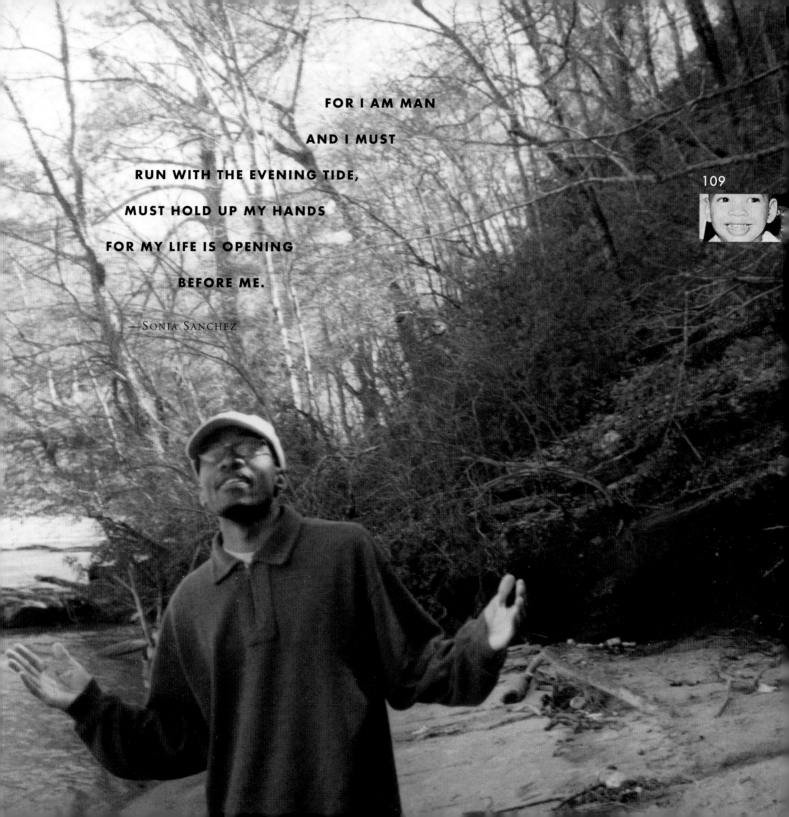

FOR I AM MAN

AND I MUST

RUN WITH THE EVENING TIDE,

MUST HOLD UP MY HANDS

FOR MY LIFE IS OPENING

BEFORE ME.

—SONIA SANCHEZ

109

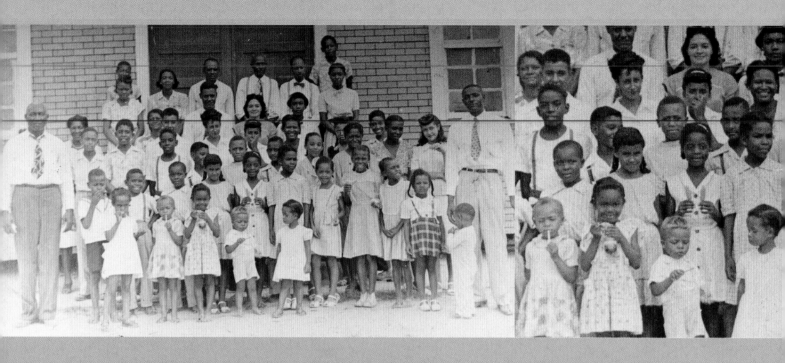

There are three things that
if a man does not know, he cannot live
long in this world:
what is too much for him,
what is too little for him,
and what is just right for him.

—SWAHILI

110

GLISTEN
glow with love

Defying a history of horror and a nowness
of brutality, Black men glisten with

strength, sparkle with wit, and glow with

love. I am the daughter, the mother, the

grandmother, the sister, the friend, and the

beloved of wonderful Black men and that

makes my heart glad.

—MAYA ANGELOU

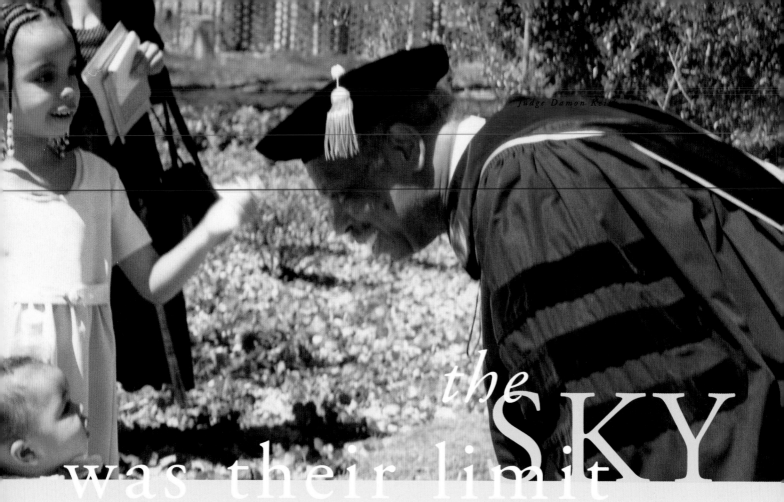
Judge Damon Kei...

the SKY
was their limit

I found a special intangible something at Morehouse in 1921 which sent men out into life with a sense of mission, believing that they could accomplish whatever they set out to do. This priceless quality was still alive when I returned in 1940, and for twenty-seven years I built on what I found, instilling in Morehouse students the idea that despite crippling circumstances the sky was their limit.

—Benjamin Mays

112

SOURCES

Photographs courtesy of: Angela Branch (p. 29), Jacqueline Sweetner Caffey (pp. 23, 54, 95, 111), Falana Carter (p. 20), Sandra Malone Goudy (p. 90), Diane Walker Hall (pp. 3, 7, 15, 19, 30, 56, 64, 66, 73, 77, 79, 100), Juanita Hammonds (pp. 37, 60, 65, 82, 102), Emma Heywood (pp. 24, 59, 70, 102), Beatrice Johnson (pp. 18, 34, 45, 47, 52, 71, 79, 102), Gloria Green Jones (p. 44), Jeremy and Lisa Lincoln (p. 68), Shirley Lusby (pp. 52, 86, 88, 89, 98), Sherlin McNeal (pp. 23, 105), Dorothy Winbush Riley (pp. 11, 12, 28, 32–33, 44, 46, 57, 76, 78, 87), and Tiaudra Riley (pp. 23, 31). The following photographs are used with the permission of the Oregon Historical Society, Portland, Oregon: *Columbus Sewall, Pioneer and Miner* (OR HI 85402) (p. 22); *The Portland Bunch of Co. 21, 166 D.R.* (IR U 37712 #133-A) (p. 92); *Jess Stahl on Grave Digger at Pendleton, Oregon, Roundup* (OR HI 12526) (p. 96).

Poetry and prose: Lucille Clifton, "The Kind of Man He Is (For Fred)," copyright 1987 by Lucille Clifton. Reprinted from *Good Woman: Poems and a Memoir 1969–1980 by Lucille Clifton* with the permission of BOA Edition, Ltd., Rochester, New York. ℮ James Weldon Johnson, from "The Creation," in *God's Trombones: Seven Negro Sermons in Verse* (New York: Viking Press, 1955). Used by permission. ℮ Naomi Long Madgett, "First Man," used by permission of the author. ℮ Benjamin Mays, "The Bridge Builder," address delivered at the Older Boys Conference, Benedict College, Columbia, South Carolina, February 26, 1926. ℮ Tiaudra Riley, "Big Brother," used by permission of the author. ℮ Howard Thurman, "Our Lives Are Spread before Us," "We Want to Be Understood," and "The Working Paper," from *Meditations of the Heart,* by Howard Thurman. Copyright 1981 by Howard Thurman. Used by permission of the Howard Thurman Foundation.

Art: Ashanti Gold Head, used by permission of the Wallace Collection, Hertford House, Manchester Square, London, England. ℮ Richard Ausdell (1815–1885), *Hunted Slave,* signed, dated 1861, canvas, 184 x 308 cm., Walker Art Gallery, Liverpool, England, used by permission of the Board of Trustees of the National Museums and Galleries on Merseyside. ℮ *Benin (Nigeria) Bronze Plaque with Two Warriors,* 17th century, H 51.2 cm, British Museum, London, England, used by permission of the British Museum Co. ℮ Elwyn Bush, *Bust of Tutankhamun,* 18" high, used by permission of the artist. ℮ Donald Calloway, *African Mask; Angel Rising,* collection of the editor; *Mr. Calloway,* collection of the artist; *Self-Portrait,* used by permission of the artist. ℮ Mike Colt, *Creation,* acrylic on canvas, 30" x 40", private collection, used by permission of the artist. ℮ Anne-Louis Girodet de Rousay-Trioson (1767–1824), *Portrait of Jean Baptiste Belly, depute de Saint Dominique a la Convention* (MV 4616), used by permission of Musee National du Chateau, Versailles, Paris, France. ℮ Jonathan Green, *Gandy Men,* 1993, oil on canvas, 72" x 72", copyright 1993 Jonathan Green Studios, Naples, Florida. Used by permission. ℮ Earl Jackson, *The Rainbow Makers,* oil on canvas, 24" x 36"; *Left Hand like Thunder, Right Hand like Lightnin',* oil on canvas, 24" x 36", used by permission of the artist. ℮ Malvin Johnson, *Elks Marching,* Aaron Douglas Collection, Amistad Research Center, New Orleans, Louisiana. Used by permission. ℮ William Henry Johnson, *Ezekiel Saw the Wheel* and *Sowing,* Aaron Douglas Collection, Amistad Research Center, New Orleans, Louisiana. Used by permission. ℮ Jamal Jones, *By Any Means Necessary,* ink on paper, 24" x 36", used by permission of the artist. ℮ *Painted Relief of a King and Queen,* late period, year 15 or later, used by permission of the Agyptisches Museum, Berlin, Germany, 15000. ℮ *Pendant Mask,* early 16th century, Nigeria, Edo Court of Benin, ivory, iron, and copper, H 9 3/8" (23.8 cm), from the Michael C. Rockefeller Memorial Collection, gift of Nelson A. Rockefeller, 1972, 1978, used by permission of the Metropolitan Museum of Art, New York, New York. ℮ Brenda Dendy Stroud, *Cry of Anguish,* mixed media, private collection; *Challenge,* mixed media, private collection; *Press On,* mixed media, private collection, used by permission of the artist. ℮ Henry O. Tanner, *Flight from Egypt,* oil on board, 9" x 12", Aaron Douglas Collection, Amistad Collection, Tulane University, New Orleans, Louisiana. Used by permission. ℮ Pheoris West, *Baptism of Christ,* artist's collection, Columbus, Ohio, used by permission of the artist.

114

A SPIRITUAL DESTINY

FROM OUR BEGINNINGS

I AM HUMAN

IF THERE IS NO STRUGGLE

STRETCH YOUR WINGS

ONLY THAT YOU LOVE

LEADERSHIP—THE SKILL AND THE WILL

EVERY TOMORROW, A VISION OF HOPE

A SPIRITUAL DESTINY

FROM OUR BEGINNINGS

I AM HUMAN

IF THERE IS NO STRUGGLE

STRETCH YOUR WINGS

ONLY THAT YOU LOVE

LEADERSHIP—THE SKILL AND THE WILL

EVERY TOMORROW, A VISION OF HOPE